PENCIL DRAWING

CATS

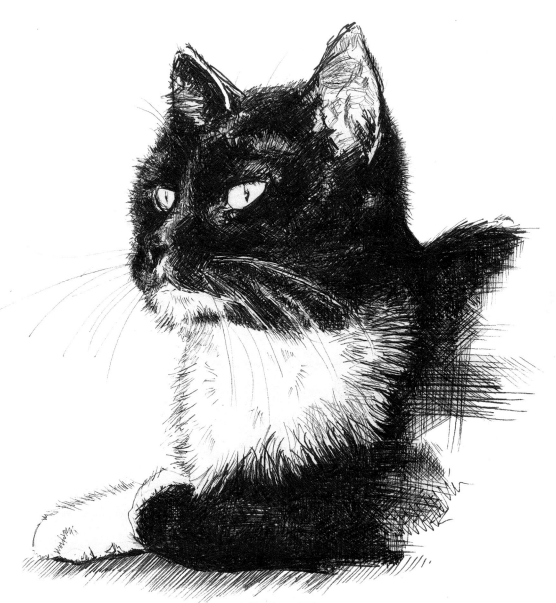

Brimming with creative inspiration, how-to projects, and useful information to enrich your everyday life, Quarto Knows is a favorite destination for those pursuing their interests and passions. Visit our site and dig deeper with our books into your area of interest: Quarto Creates, Quarto Cooks, Quarto Homes, Quarto Lives, Quarto Drives, Quarto Explores, Quarto Gifts, or Quarto Kids.

First published in German as *Katzen! Das Zeichenbuch* by Anja Dahl

Copyright © 2016

World rights reserved by Christophorus Verlag GmbH & Co. KG, Rheinfelden/Germany

Published in English in 2018 by Walter Foster Publishing, an imprint of The Quarto Group.

Artwork/Text by Anja Dahl, except as noted below:

Pages 6-7: © cw-design, www.photocase.com, Bild-Nr. 100118. Page 9: akg-images, Berlin. Pages 26, 60: © andrea, www.photocase.com, Bild-Nr. 98982. Page 28: © carlitos, www.photocase.com, Bild-Nr. 57196. Pages 29, 90, 92: © lp-webdesign.de, www.photocase.com, Bild Nr. 136272. Page 31: © SitePoint, www.photocase.com, Bild-Nr. 127505. Pages 34, 42: B. Waldschmidt. Page 35: © trepavica, www.photocase.com, Bild-Nr. 124793. Page 38: © Sisk4, www.photocase.com, Bild-Nr. 116648. Page 51: S. Fritzler. Page 52: F. Schuppelius. Pages 65, 88-89, 96: B. Sopp. Pages 70, 85: © lube, www.photocase.com, Bild-Nr. 122419. Page 72: © andybahn, www.photocase.com, Bild-Nr. 87123. Pages 74-77: © womanticker, www.photocase.com, Bild-Nr. 28387. Page 78: © Schneggo, www.photocase.com, Bild-Nr. 127028. Page 80: H. Dahl. Page 86: © kimako, www.photocase.com, Bild-Nr. 87727. Page 94: © Gano10, www.photocase.com, Bild-Nr. 132780. Page 98: © mamboben, www.photocase.com, Bild-Nr. 42950.

Additional credits: Photographs on page 12 ("Erasers," "Blending Stumps"), page 14, pages 107-111 ("Portrait Gallery") © Shutterstock. Photographs on page 12 ("Drawing Paper," "Sketch Pads"), page 13, page 15, page 21 ("Tracing and Transferring") © WFP. Photographs on page 16 © Alain Picard. Photographs on page 17 © Jim Dowdalls. Artwork on pages 18-19 © Steven Pearce. Artwork on pages 20-21 ("Animal Textures") © Mia Tavonatti, except page 21 ("Nose") © Nolan Stacey. Artwork on pages 22-23 © Mia Tavonatti. Text on pages 12-23 © WFP.

Walter Foster Publishing titles are also available at discount for retail, wholesale, promotional, and bulk purchase. For details, contact the Special Sales Manager by email at specialsales@quarto.com or by mail at The Quarto Group, Attn: Special Sales Manager, 100 Cummings Center, Suite 265D, Beverly, MA 01915, USA.

ISBN: 978-1-63322-483-4

Printed in China

10 9 8 7 6 5 4 3 2

MIX
Paper from responsible sources
FSC® C016973

PENCIL
DRAWING
CATS

ANJA DAHL

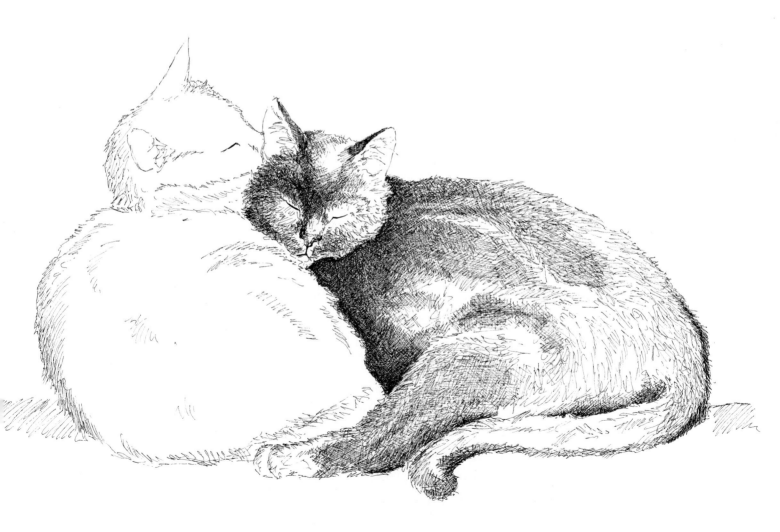

CONTENTS

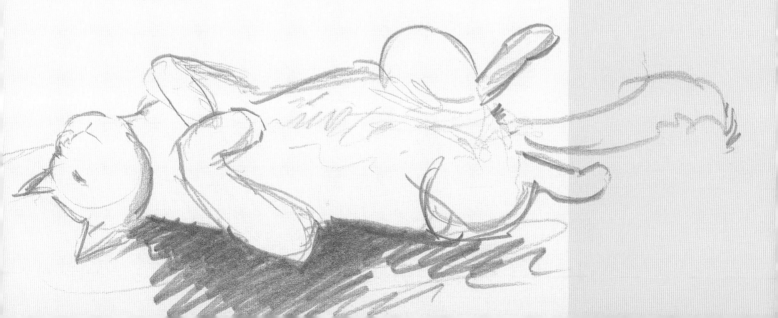

FOREWORD

Leonardo da Vinci once said: "The smallest feline is a masterpiece." And how right he was! The cat's refined, dignified nature makes this creature particularly difficult for the artist to capture on canvas.

Since time immemorial, the cat's mysterious character has provided inspiration to poets, philosophers, and artists. It's hard to say what makes these animals so captivating, but one thing's for certain: the effect they have on us is just as strong now as it was in bygone centuries.

These gentle, mystical creatures have slinked their way into many works by the world's greatest artists and writers. Charles Dickens's cat, for instance, attempted to get the writer's attention (and strokes!) by snuffing out the author's reading candle with its paw. And according to Pablo Picasso, the cat was the most considerate, attentive companion a person could ever wish for.

The figure of the cat holds a special place in many pieces of world literature, as well. Homer and Ovid, Dante Alighieri, Goethe, E. T. A. Hoffmann, Charles Baudelaire, Oscar Wilde, Edgar Allan Poe, and Lewis Carroll are just some of the writers who have penned a memorial to the cat. The poet Rainer Maria Rilke is quoted as saying, "Life and a cat...adds up to an incalculable sum, I swear," proving that he too had found a muse in the delicate creature.

The cat feels out the world with its paws.
Jules Renard

And who could ever forget Truman Capote's famous novel *Breakfast at Tiffany's* and the anonymous cat that runs up to Holly, thus becoming a temporary companion in her turbulent life? Holly never names the ginger cat, as she insists it doesn't belong to her. And in the final scene of the film, we see a vivid image of the cat soaked with rain.

The aim of this book is to show you how to capture the magic of cats in art. In addition to providing in-depth insight into the visual characteristics of these wonderful animals, the book also clearly demonstrates the techniques you need to learn to draw these magnificent creatures. Take inspiration from your surroundings, and perhaps your own pussycat can even serve as a model! By completing the movement studies and helpful exercises in this book, the magical world of cats will be revealed to you, step-by-step.

Have fun, and happy drawing!

THE CAT IN ART: A BRIEF INTRODUCTION

The figure of the cat has been a feature of the visual arts since early in our history and has inspired humans to create art of all kinds. The ancient Egyptians worshipped the cat goddess, Bastet. Egyptian statues testify to an early fascination with the cat as a domesticated yet independent creature with a special role in the household: a creature that held special sway—both positive and negative—over human emotions. The figure of the cat has also found resonance in other cultures. In South America, dancing jaguar figures are depicted in Mayan wall art; while in Scandinavia, Freya, the goddess of love and beauty, rides a carriage drawn by two cats.

The lion is often represented in the form of a sphinx (a lion with a human head) and was considered a symbol of strength and power in Egypt and beyond. The British Museum in London, for instance, has many imposing specimens from Assyria in its collections that drive home the idea of the lion as a symbol of power. Big cats have also become accepted in the West as a symbol of sovereignty. The winged lion of St. Mark adorns the Venetian Arsenal, for example, and is the heraldic animal seen in the city's coat of arms.

In medieval Europe, superstition, fear, and ignorance provided fertile ground for hysteria about witchcraft, witch hunts, and the persecution of cats. A papal bull even described the black cat as Lucifer incarnate, so it's little wonder that cats featured so rarely in pictures from the time.

Only during the Renaissance did people start once more to view the cat as anything other than a creature of mystery and diabolical evil. Leonardo da Vinci, for instance, made numerous, incredibly life-like movement studies of the cat. In his drawing *Vergine del gatto* ("Virgin and Child with Cat"), da Vinci placed the cat alongside the Christ Child, giving it special significance. Pieter Bruegel the Elder also painted the cat, as did Albrecht Dürer. Unable to resist the charm of this animal, Dürer created a woodcut titled "Winged Lion" around 1500.

At the end of the 18th century, the cultural landscape was increasingly dominated by early industrialization. During this time, the freedom-loving, untamed nature of the cat became a particular focus in art. The literature and visual arts of the Enlightenment saw the cat as a poster child for an increasingly urban middle class that had become estranged from nature. The cat had succeeded in retaining its independence, and so became symbolic of unbridled human desires. For 18th century Romanticists, on the other hand, the cat's mysterious and supernatural, spiritual nature was of particular significance.

In the 19th and 20th centuries, many artists applied themselves to the motif of the cat, making it a common feature in Impressionist painting. Pierre-Auguste Renoir included motifs of women and cats in many of his works, such as "Woman with

a Cat" and "Portrait of Julia Manet with a Cat." Other Impressionists, such as Pierre Bonnard and Lovis Corinth, also chose to depict humans and cats together in their paintings. This penchant for cat motifs was shared by the Expressionists, including Franz Marc, Ernst Ludwig Kirchner, and Max Pechstein, to name just a few. In the 20th century, the cat is found in works by Max Beckmann as well as sketches by Paul Klee; the latter even wrote letters to his own cats and dedicated paintings to them. Pablo Picasso was also a cat lover, and in fact, his painting, "Dora Maar au Chat," is one of the world's most expensive works of art.

I hope this brief chapter has given you an insight into the wide spectrum that cats occupy in art and how they have been a constant source of inspiration for artists throughout the ages.

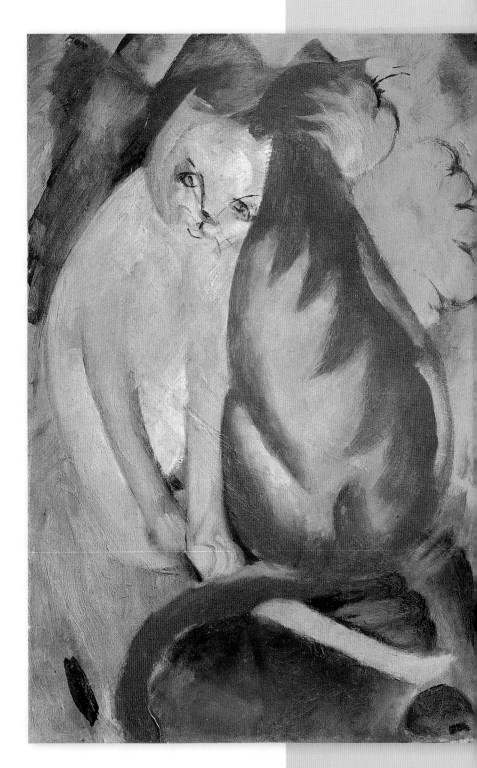

Cats, Red and White, Franz Marc
Franz Marc (1880–1916), 1912. Oil on canvas,
52 x 35 cm. Hamburg, Dr. Rainer Horstmann,
art dealer.

CHAPTER ONE

GETTING STARTED

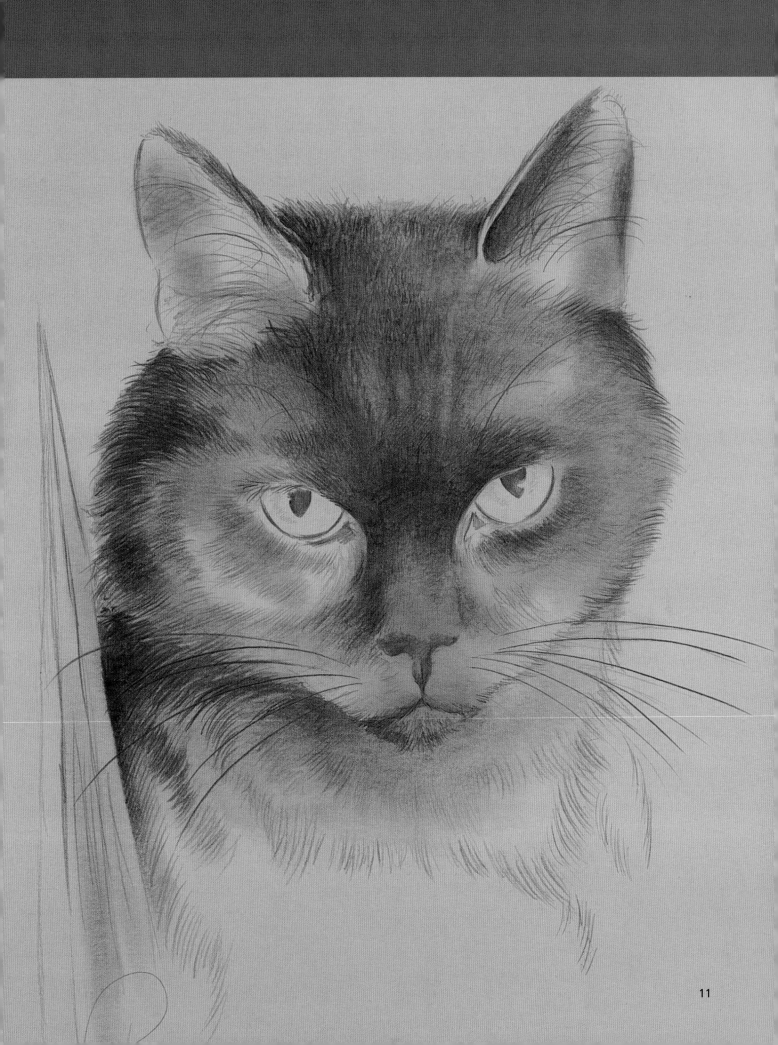

GRAPHITE PENCIL

Drawing Paper

Drawing paper is available in a range of surface textures (called "tooth"), including smooth grain (plate finish and hot pressed), medium grain (cold pressed), and rough to very rough. Cold-pressed paper is the most versatile and is great for a variety of drawing techniques. For finished works of art, using single sheets of drawing paper is best.

Sketch Pads

Sketch pads come in many shapes and sizes. Although most are not designed for finished artwork, they are useful for working out your ideas.

Erasers

There are several types of art erasers. Plastic erasers are useful for removing hard pencil marks and large areas. Kneaded erasers (a must) can be molded into different shapes and used to dab at an area, gently lifting tone from the paper.

Blending Stumps

These paper "stumps" can be used to blend and soften small areas when your finger or a cloth is too large. You also can use the sides to blend large areas quickly. Once the tortillons become dirty, simply rub them on a cloth, and they're ready to go again.

Drawing Implements

Drawing pencils, the most common drawing tool, contain a graphite center. They are categorized by hardness, or grade, from very soft (9B) to very hard (9H). A good starter set includes a 6B, 4B, 2B, HB, B, 2H, 4H, and 6H. See below for a variety of drawing tools and the kinds of strokes you can achieve with each one.

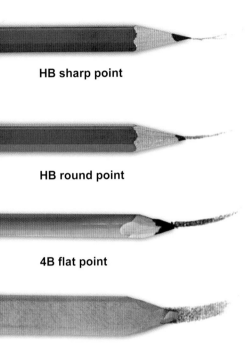

HB sharp point

HB round point

4B flat point

Flat sketching

HB An HB with a sharp point produces crisp lines and offers good control. A round point produces slightly thicker lines and is useful for shading small areas.

Flat For wider strokes, use a 4B with a flat point. A large, flat sketch pencil is great for shading bigger areas.

Charcoal 4B charcoal is soft and produces dark marks. Natural charcoal vines are even softer and leave a more crumbly residue on the paper. White charcoal pencils are useful for blending and lightening areas.

Conté Crayon or Pencil Conté crayon is made from very fine Kaolin clay and is available in a wide range of colors. Because it's water-soluble, it can be blended with a wet brush or cloth.

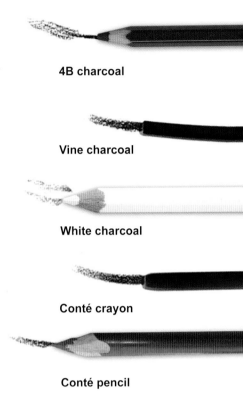

4B charcoal

Vine charcoal

White charcoal

Conté crayon

Conté pencil

Sharpening Your Pencils

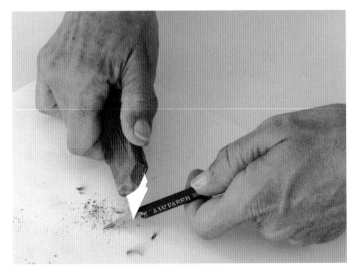

A Utility Knife Use this tool to form a variety of points (chiseled, blunt, or flat). Hold the knife at a slight angle to the pencil shaft, and always sharpen away from you, taking off a little wood and graphite at a time.

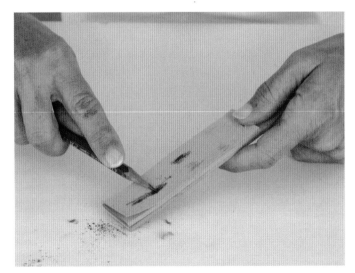

A Sandpaper Block This tool will quickly hone the lead into any shape you wish. The finer the grit of the paper, the more controllable the point. Roll the pencil in your fingers when sharpening to keep its shape even.

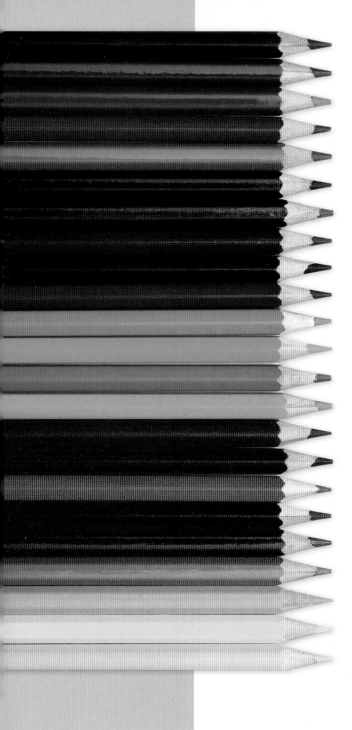

COLORED PENCIL

Colored pencil artwork requires few supplies. Many pencil brands are sold at reasonable prices in art stores and online; however, it's best to purchase artist-grade, professional pencils whenever possible. Student-grade pencils will not produce lasting works of art because the colors tend to fade quickly.

Colored Pencils

There are three types of colored pencils: *wax-based, oil-based*, and *water-soluble*. You should purchase a few of each and test them to see what looks great on paper.

Wax-Based Wax-based pencils are known for their creamy consistency and easy layering. However, they wear down quickly, break more frequently, and leave pencil crumbs behind. This is easily manageable with careful sharpening, gradual pressure, and the use of a drafting brush to sweep away debris. Wax bloom, a waxy buildup that surfaces after numerous layers of application, may also occur. It is easy to remove by gently wiping a soft tissue over the area.

Oil-Based These pencils produce generous color with little breakage. There is no wax bloom and little pencil debris. They sharpen nicely and last longer than wax-based pencils. They can be harder to apply, but they are manageable when establishing color and building layers.

Water-Soluble These pencils have either wax-based or oil-based cores, which allow for a watercolor effect. Use them dry like a traditional colored pencil, or apply water to create a looser, flowing effect. This is especially nice for slightly blurred backgrounds.

Choosing Paper

Smooth Bristol paper is a hot-pressed paper that accepts many layers of color. It allows you to build up your colors with a lot of layering and burnishing, which involves using strong pressure to create a polished, painterly surface. Additional surfaces include velour paper, museum board, suede mat board (great for animal fur), illustration board, wood, and sanded paper, which eats up pencils quickly but presents a beautiful, textured look. Experiment with different surface types, colors, and textures until you find what works for you.

Textured paper has defined ridges that accept many colored pencil layers without compromising the paper.

Smooth paper is less likely to accept multiple applications of color

Understanding Paper Tooth Choose paper based on the tooth, or paper texture. Rough paper contains more ridges than smooth paper. The paper's tooth will determine how many layers you can put down before the paper rips. Hot-pressed paper has less tooth and a smoother texture. Cold-pressed paper has more tooth and a rougher texture, which is excellent for water-soluble pencils.

Soft Pastels

PASTEL

When selecting pastels, it is important to understand the different qualities of each type of pastel. There are three main types: soft, hard, and pastel pencils. Beginners should collect a large assortment of artist-quality soft pastels (70 or more) and a smaller selection of hard pastels.

Soft Pastels Good-quality soft pastels are composed of almost pure pigment, with a very small amount of filler and just a touch of binder to hold them together. As a result, they are more sensitive and crumble easily. Soft pastels are incredibly brilliant, with beautiful covering strength. The degree of softness and shape varies depending on the brand. Traditional soft pastels are round, yet many are currently produced in a shorter square format. Thanks to the popularity of the pastel medium, there is an ever-growing selection of quality soft pastels on the market today. But as a beginner, you can explore the available pastels to find what works for you.

Hard Pastels Hard pastels are typically thinner and longer than soft pastels. They also contain more binder and less pigment. Hard pastels do not fill the tooth, or grain, of the paper as quickly as soft pastels, nor do they have quite the same tinting strength, yet they can be used interchangeably with soft pastel. Hard pastels can be sharpened to a point with a razor because of their consistency. They work well for a linear drawing approach, making them ideal for applying small details as well as laying in the preliminary drawing. Hard pastels are great for portrait details. Keep a selection of earth tones on hand, as well as neutral accents such as black and white.

Pastel Pencils Pastel pencils are essentially a hard pastel core in a protective wood covering. They are designed to be sharpened to a point and can be used either for detail work or sketching. You can buy pastel pencils in full sets or individually.

PEN & INK

Dipping Pens

Pens are a very traditional way to work with ink; steel and copper pen points are dipped into an ink bottle, or other liquid reservoir, to refill the pen. The amount of ink collected on the nib depends on the size of the nib. The thickness of the drawn line depends on the amount of pressure applied, as well as the size of the nib. The smallest pen points carry only as much ink as their surface area allows and must be repeatedly dipped into the ink.

Larger nibs have a two-tiered ink collection system that holds an amount of ink directly above the point; the ink is released as pressure is placed on the paper with the nib. There are different types of large nib tips: flat, round, and square. Each type has several different sizes. The B (round tip) 5½ is a good choice for all-purpose drawing. These types of drawing nibs allow for a wide range of expressive line weights.

Ink

Inks have been used for thousands of years, for both written documents and art. Today, inks consist of soluble dyes in a shellac solution and are either water-soluble or waterproof. They are available in a variety of colors, in addition to black. Inks may be mixed with water to create washes with a variety of different values.

BASIC DRAWING TECHNIQUES

Blending

When you use a blending tool, you move already-applied graphite across the paper, causing the area to appear softer or more solid. Use a circular motion when blending to achieve a more even result. Here are two examples of drawing techniques blended with a tortillon.

Burnishing

When you use a soft pencil, the result may appear grainy depending on the tooth of the paper. In some of your drawings, you may desire this look. However, if the area requires a more solid application, simply use a pencil that is a grade or two harder to push, or "burnish," the initial layer of graphite deeper into the tooth of the paper.

Circular

Move the pencil in a continuous, overlapping, and random circular motion. You can use this technique loosely or tightly, as shown in this example. You can leave the circular pattern as is to produce rough textures, or you can blend to create smoother textures.

Erasing

Pencil and kneaded erasers are a must. The marks on the left side of this example were created with a pencil eraser, which can be used for erasing small areas. If you sharpen it, you can "draw" with it. The kneaded eraser is useful for pulling graphite off the paper in a dabbing motion, as shown on the right side.

Linear Hatching

In linear hatching, use closely drawn parallel lines for tone or shading. You can gradually make the lines darker or lighter to suggest shadow or light. Draw varying lengths of lines very close and blend for a smooth finish. You can also curve your lines to follow the contour of an object, such as a vase.

Negative Drawing

Use your pencil to draw in the negative space—the area around the desired shape—to create the object. In this example, the vine and leaves are in the positive space.

Scribbling

You can use random scribbling, either loose or tight, to create a variety of textures. Lightly blend the scribbling to produce different effects.

Stippling

Tap the paper with the tip of a sharp pencil for tiny dots or a duller tip for larger dots, depending on the size you need. Change the appearance by grouping the dots loosely or tightly. You can also use the sharp tip of a used stump or tortillon to create dots that are lighter in tone.

Applying Graphite with a Blender

Chamois Using a chamois is a great way to apply graphite to a large area. Wrap it around your finger and dip it in saved graphite shavings to create a dark tone, or use what may be already on the chamois to apply a lighter tone.

Stump Stumps are great not only for blending but also for applying graphite. Use an old stump to apply saved graphite shavings to both large and small areas. You can achieve a range of values depending on the amount of graphite on the stump.

ANIMAL TEXTURES

Before creating a full cat portrait, get to know the general shapes and textures that make up each feature. As you practice rendering the features of a variety of cats and kittens, notice the subtle changes in shape, value, and proportion that distinguish each breed.

Short Hair

Apply short strokes in the direction of fur growth. Then apply darker strokes in irregular horizontal bands. Pull out highlights with an eraser.

Long Hair

Use longer, sweeping strokes that curve slightly, and taper the hairs to a point at the ends.

Smooth Coat

Use sweeping parallel pencil strokes, leaving the highlighted areas free of graphite. Alternate between the pencil tip and the broad side for variation.

Wavy Coat

Stroke in S-shaped lines that end in tighter curves. Leave the highlights free of graphite and stroke with more pressure as you move to the shadows.

Whiskers

Apply a series of dots to indicate the whisker markings. Fill in the fur as you have elsewhere; then, with the tip of a kneaded eraser, lift out thin, curving lines.

Nose

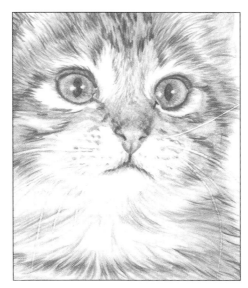

Most animal noses have a bumpy texture that can be achieved with a very light scale pattern. Add a shadow beneath the nose; then pull out highlights with a kneaded eraser.

Tracing and Transferring

Step 1 Place a sheet of tracing paper on top of your photo reference and trace the major outlines of the animal.

Step 2 Place transfer paper—thin sheets coated on one side with graphite—on top of your drawing paper, graphite-side down; secure the transfer paper with artist's tape.

Step 3 Place your traced drawing on top of the transfer paper and lightly trace the lines with a pencil or a stylus. The lines will transfer to the drawing paper below.

Step 4 Check underneath the transfer paper occasionally to make sure the lines that have transferred aren't too light or too dark.

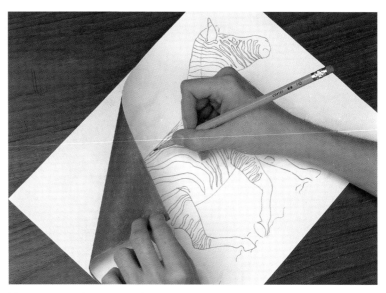

You can purchase transfer paper at an art-supply store, or you can make your own by covering the back of the traced image with an even layer of graphite.

BASIC STROKES

Learning to draw any subject begins with mastering basic strokes to create form. Start with clean, simple lines and add as little or as much detail as you choose.

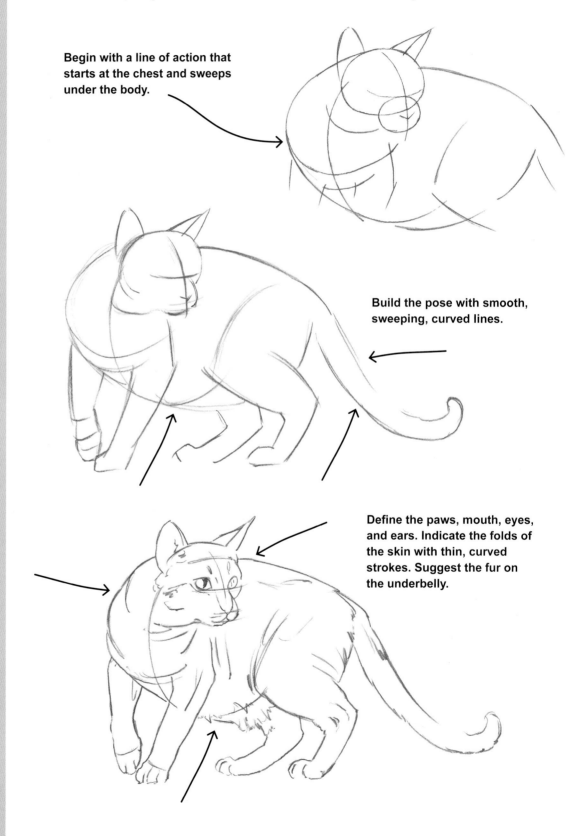

Begin with a line of action that starts at the chest and sweeps under the body.

Build the pose with smooth, sweeping, curved lines.

Define the paws, mouth, eyes, and ears. Indicate the folds of the skin with thin, curved strokes. Suggest the fur on the underbelly.

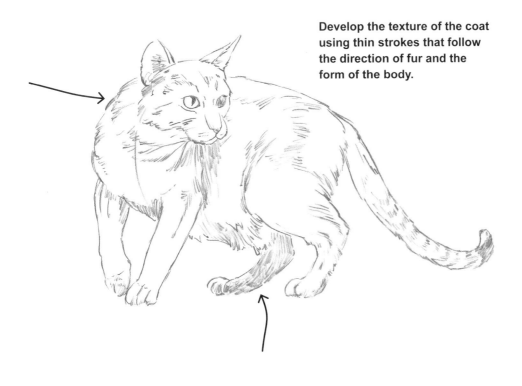

Develop the texture of the coat using thin strokes that follow the direction of fur and the form of the body.

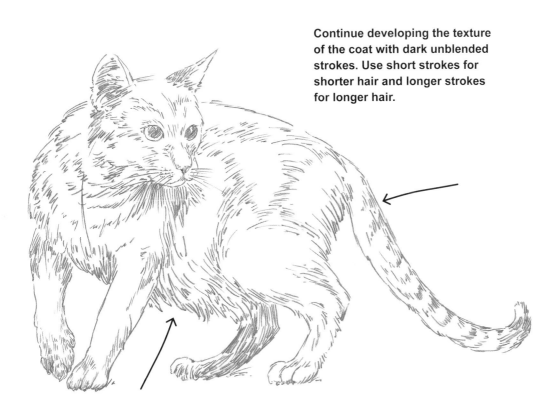

Continue developing the texture of the coat with dark unblended strokes. Use short strokes for shorter hair and longer strokes for longer hair.

ANATOMY OF THE CAT

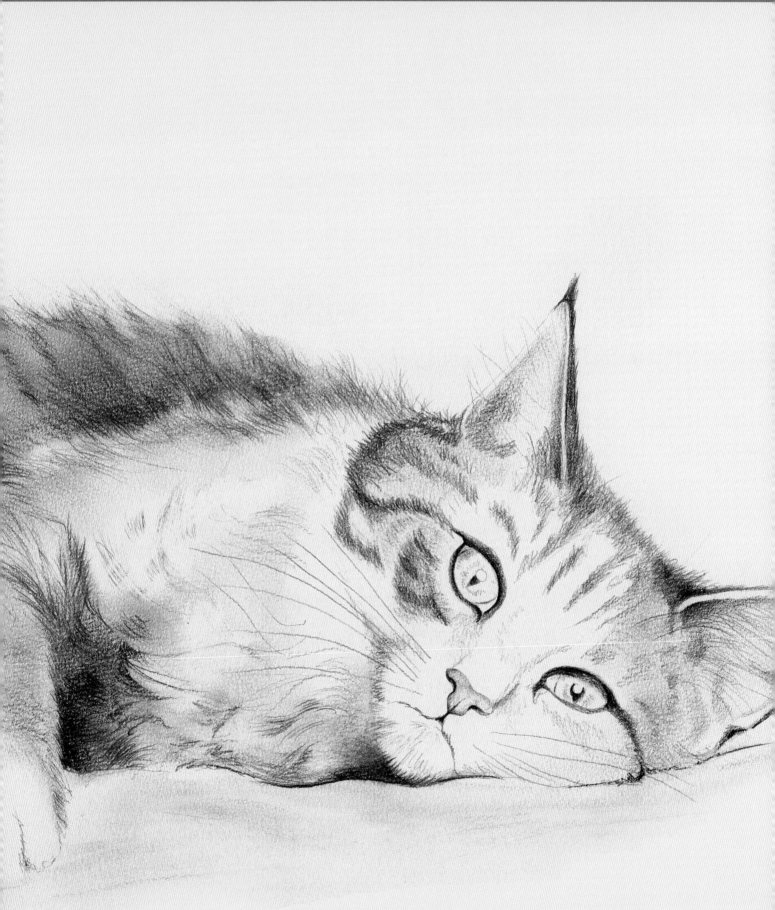

ANATOMY

Bone Structure, Form & Musculature

The cat's graceful movements are due in part to its extremely flexible skeletal structure, which helps it execute a variety of athletic movements that are essential in the wild. The cat's graceful nature is reflected in its body language, as well as in its delicate skeleton and slender muscles.

Cats walk on their toes. They also have long hind legs, which give them the power to cover remarkable distances in one jump. The tail is made up of a number of tiny bones, which allow it to move lithely from side to side. In comparison with other mammal skulls, cat skulls are rather round and unremarkable. The contours of a cat's body are mostly covered by soft, fluffy fur so you may be tempted to pay little attention to the musculature when you start drawing. It is, however, important to familiarize yourself with the form and muscle of your subject so that you'll be able to factor them into your drawing. When you look at a cat, the most visible muscles are the thighs. The shoulders also feature tiny bulging muscles that become more prominent as the cat moves, walks, or jumps.

Unlike humans, cats walk on their toes.

Head

In profile, head shape varies significantly from breed to breed. The heads of Siamese, European Shorthair, and Persian cats are particularly distinctive. Of the three, the Siamese has the longest muzzle and a relatively flat head. The head of the European Shorthair, on the other hand, has much more balanced proportions. Persians have a rather flat, and sometimes slightly concave facial contour. This breed also has a small snub nose and prominent cheeks. When viewed from the front, the cat's head can appear round, triangular, or square depending on its breed, size, and weight. If you look at the different stages of development from kitten to cat in one individual breed, you can also see examples of how a cat's head shape changes over time. As it grows, a kitten's face changes. It starts off round but becomes steadily more triangular during its first few months of life. Only when the animal is fully grown does its head take on the distinctive shape of its breed.

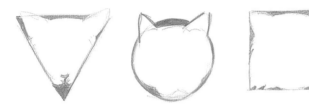

Triangular, round, and square head shapes

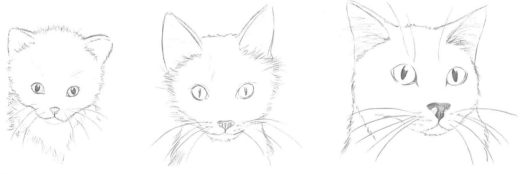

As the kitten grows, the shape of its head and the ear-to-head ratio changes significantly.

Ears

A cat's ears also change during the first few months of growth. The ears initially look tiny in comparison to the kitten's head, but they seem to grow rapidly as the cat matures. The ears only come back into proportion once it is a full-grown adult cat.

There isn't a lot of variation in ear shape, however. Often, the only thing that differs from cat to cat is the ear size, and usually, it is coat length that determines how prominent the ears look. A Siamese cat's ears are very noticeable, as the breed's short fur draws more attention to them. Persians, on the other hand, seem to have smaller ears because the hair is long. The outside of a cat's ear is surrounded by a thick covering of hair. On the inside, however, the skin is visible and covered by a few fine, very long hairs. Tiny folds of skin can also be seen along the lower edge of the outer ear, forming a smooth transition between the ear and the cat's head. The position of the ears can also tell us a lot about a cat's mood!

A cat's ears are usually either oval or pointed.

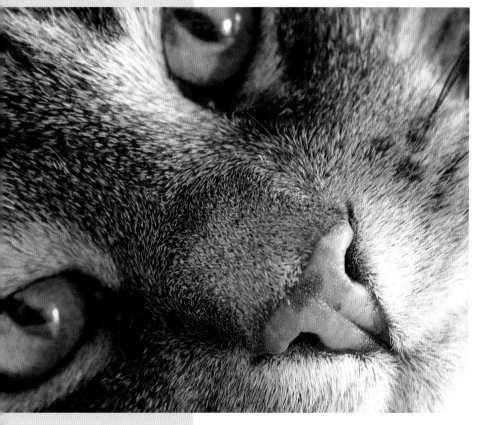

Eyes

There's something magical and mysterious about a cat's eyes. They have an aesthetic purity and are expressive and profound. In color, they range from yellow to orange and from green and gray to blue. In most cases, a cat's eyes are almond-shaped; however, they may be rounder depending on the breed (in the case of Persians, for instance).

The eyelashes are usually rooted in the fur on the cat's forehead and don't stick out as much as they do in other animals. The eye is surrounded by a rim of lighter or darker skin, which varies from cat to cat. This rim is particularly obvious in tabby cats with black fur around their eyes. The inner corner of the eye drops down into the facial fur in a line measuring approximately half an inch.

A cat is a lion in a jungle of small bushes.
Indian proverb

When the pupils are constricted, they form a sharp, black line; the more the pupils open, the more oval the shape becomes. When fully dilated, they form a circle that, depending on the lighting, can make the eye look completely black. If the eyelids fall over the outer edge of the iris, the pupil may look like it extends up to the edge of the iris when it doesn't.

The iris around the pupil usually has a circular, fragmented pattern. Light reflected in the eyes usually appears as little white dots or distorted squares. When you're drawing, it's important that you add these details in so that your drawing looks as realistic as possible!

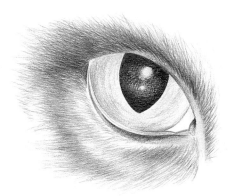

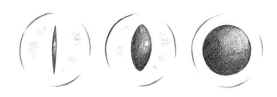

Cat eyes change depending on the light. From left: the eye in bright light; the eye in moderate light; the eye in dim light.

The eyelid extends far beyond the eye itself.

Nose

In many drawings, the cat is given a simple triangular nose. Although this may look quite realistic, it can soon look clumsy if the nose's intricate internal structure isn't copied as well. For this reason, be sure—at the very least—to add in the arches (the delicate nostrils) sweeping left and right from the point where the nose divides in the middle. The nose isn't split into two halves at the top. The fur on the bridge of the nose starts in a little recess directly above the nose, and the hair gradually becomes longer as it travels up toward the forehead. Depending on the color of the cat, the nose can either be pink or black.

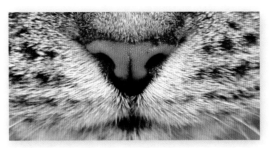

The nose is shaped like a rounded triangle with sweeping nasal wings. The bottom of the nose splits in two in the middle.

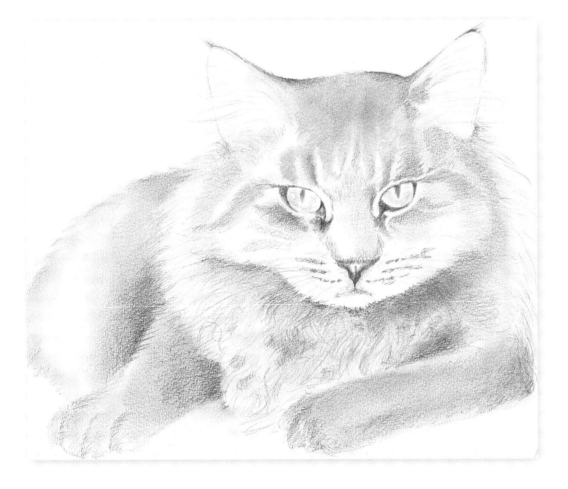

Mouth & Chin

The cat's mouth and chin aren't very visible. The mouth usually looks like a thin line, while the exact shape of the chin depends on the breed, and slopes backward. A Norwegian Forest Cat's mouth, for instance, can be square-shaped. The Chartreux, on the other hand, has quite a weak chin, while the Russian Blue's chin is very pronounced. In other breeds of cat, the chin can either be round or pointed.

A cat's mouth is practically invisible. From the front, it usually looks like a small triangle and from the side, like a thin line.

Whiskers

A cat's wire-like whiskers can either be black or white. They help the cat navigate as it patrols its kingdom. For example, when slinking through a hole in a fence for the first time, the cat's whiskers will stroke against the edges of the opening, telling the cat whether its body will be able to fit through as well. Drawing white whiskers requires a little more effort and skill, as the outline of each whisker has to be reproduced by "drawing around" each one.

Some cats also have contrasting "eyebrows" above their eyes, which are subtle in some and more pronounced in others. You should also include these whiskers in your drawing, as the small lines can sometimes help make your cat's face look more expressive.

When drawing, you should make sure that light-colored whiskers stand out against dark fur.

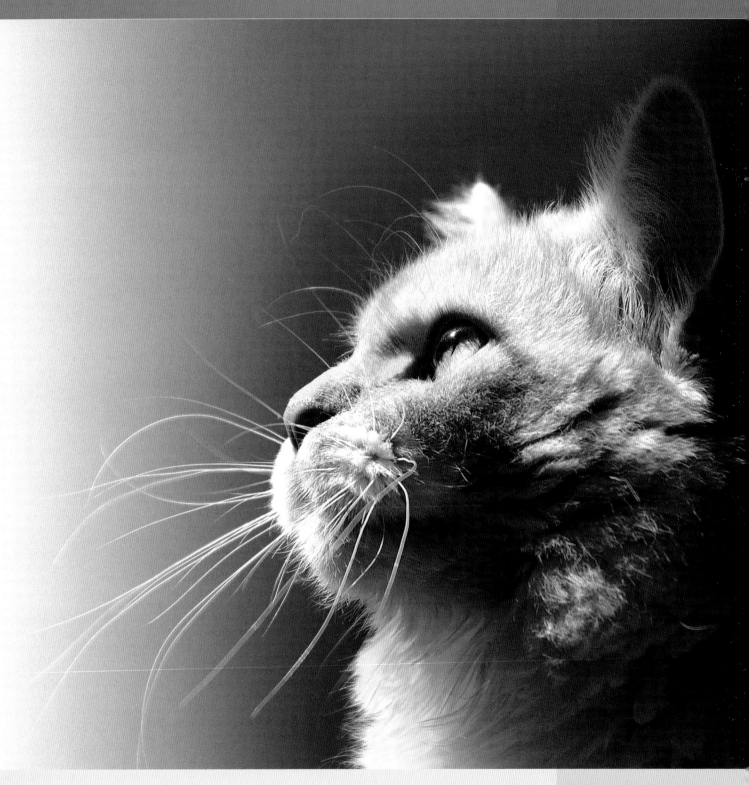

Cats are a mysterious kind of folk.

There is more passing in their minds than we are aware of.

Sir Walter Scott

Body Types

Cat bodies also vary significantly from breed to breed. Viewed separately from the limbs, the torso can be trapezoidal and compact, long and thin, or thick and round. As with humans, the cat's lifestyle and diet can also have an impact on its body shape. The Norwegian Forest Cat is naturally stout and muscular; however, it is longer than the similar Maine Coon. The medium-sized Russian Blue has a stout build but is also slightly longer than other breeds. The Persian, on the other hand, has a much shorter bone structure. The Siamese has a strikingly graceful frame, while the Chartreux has a distinctive rounded head.

Persian

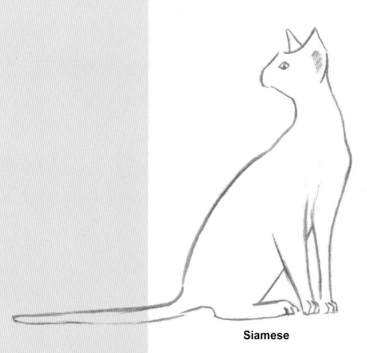

Siamese

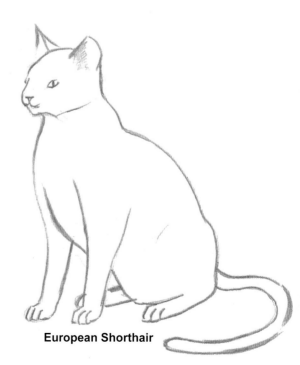

European Shorthair

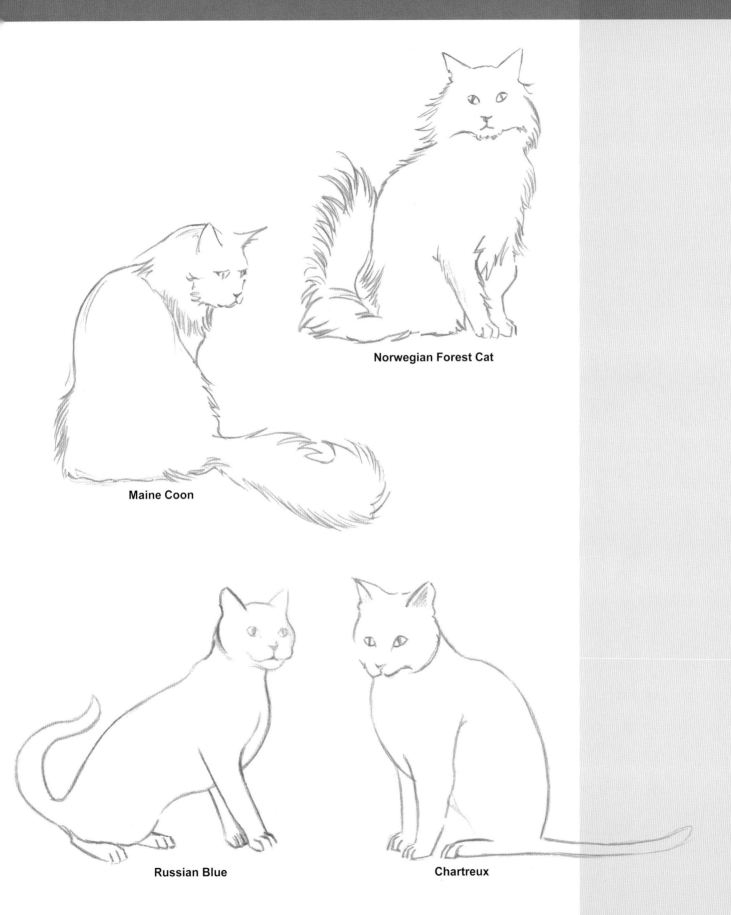

Norwegian Forest Cat

Maine Coon

Russian Blue

Chartreux

Paws

No matter how small or unremarkable a cat's paws may look, make sure that you pay attention to them when drawing. To draw realistic-looking paws, you should include the outline of the four toe pads on the front of each paw. These pads are mostly covered with fur, and because cats walk on their toes, their paws look short and compact. Retractable claws are located in the center of the pads (when viewed from the front) and extend when pressure is applied or the muscles around them tense. These claws give the cat a firm grip on the ground and also allow it to attack prey quickly.

A cat's hind legs are similar to a hare's.

The outline of each toe is nearly visible through the fur.

34

Legs

When drawing a cat, the most challenging part is often the legs. Compared to human legs, it's more difficult to tell what position a cat's legs are in. The thighs of the front and hind legs are covered with fur and skin, which makes them hard to see. The ulnae of the front and lower-hind legs, on the other hand, can be seen much more clearly. Their abundant fur means that the legs of long-haired breeds look stockier than they actually are. The legs of short-haired cats, however, look thin and wiry.

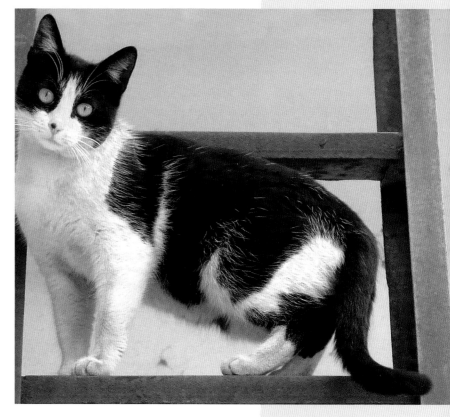

Only the lower part of the hind legs is visible. The top is covered with fur and skin.

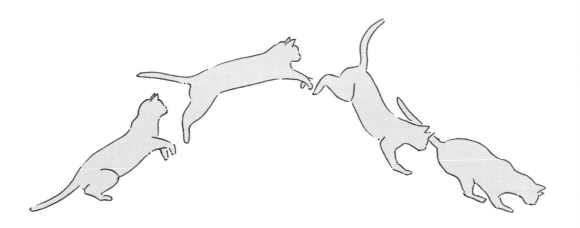

There is no more intrepid explorer than a kitten.

Jules Fleury-Husson

In this sequence at left, the shape and position of the cat's legs at different stages of a jump can be clearly seen.

Tip: Practice sketching each part of the cat's body, working to master your technique.

CHAPTER THREE

PATTERNS & COLORS

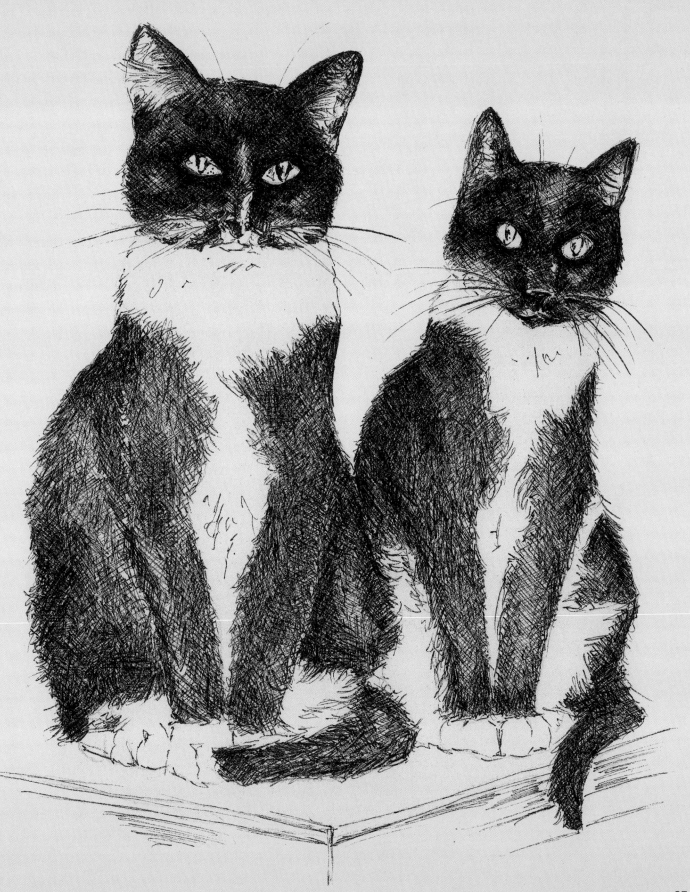

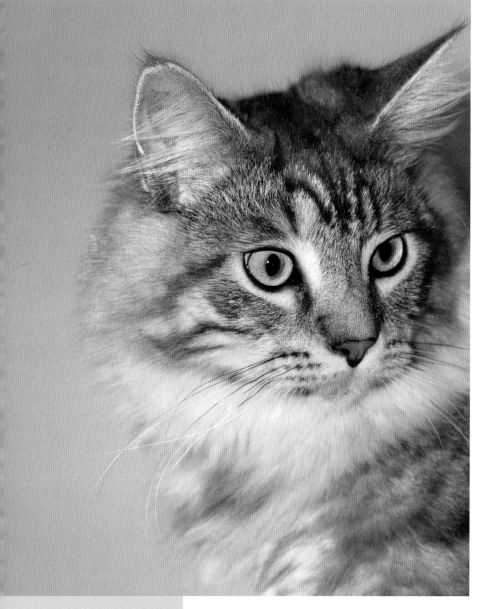

Pattern

There are around 40 different breeds of cat divided into three main groups: short-haired, medium-haired, and long-haired.

The coat of some short-haired breeds can be denser and shorter than in others, giving it a subtle, velvety sheen. The Siamese is the most extreme example of this, although it can also be seen in the Chartreux and Russian Blue. This type of coat can be reproduced beautifully using simple shading techniques.

Cats with a medium-length coat include the Maine Coon and the Norwegian Forest Cat. Their dense, silky fur is short on the head, shoulders, and legs, and longer on the back, neck, and flanks. This effect can be created either by reproducing each individual, chunky section of hair or by drawing lots of small, delicate hairs.

A typical example of a long-haired cat is the Persian, which has a distinctive long coat. The hairs are soft and light, giving the coat an exceptionally plush appearance. This fur texture can be rendered through shading and outlining the outer contours of the fur.

Everyone should have a dog that will worship him and a cat that will ignore him.

Dereke Bruce

Short fur

Medium fur

Long fur

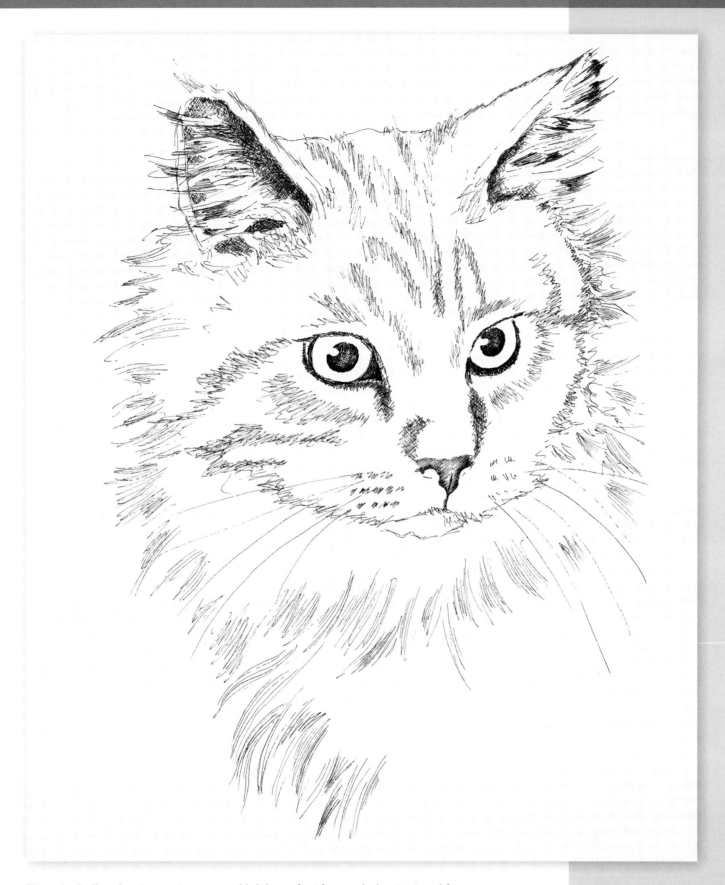

Though challenging to master, pen and ink is perfect for rendering textured fur.

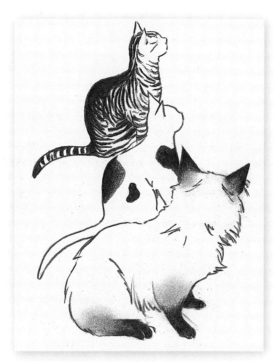

Top to bottom: mackerel tabby, patched, colorpoint

Although two individual cats may look like twins, the color and pattern of their fur will be unique. Animals with a common pattern, such as the aristocratic white collar and socks "tuxedo" pattern, can sometimes look identical at first glance. Upon taking a closer look, however, one cat will have a white spot on its face and the other will have a white tip on its tail. Coat markings, therefore, give every animal its own distinctive appearance.

Coat Patterns

Experts and cat breeders use different terms to describe different coat patterns, and specialist terms are often used that can be confusing for non-experts: the term "tabby," for instance, is used to refer to cats with any type of marking on their coat. Coat patterns fall into the following categories:

Mackerel: Mackerel tabbies have long stripes running from their head down their back. The pattern drops down over the flanks and covers the legs and the tail in rings.

Blotched, marbled, classic: The only difference between the mackerel tabby and the blotched tabby is that blotched tabbies have wider stripes.

Spotted: A spotted pattern features lots of solid-colored or bicolor dots. "Bicolor" means that each dot contains an additional dot in a different color. These markings are known as rosettes. A good example of a cat with a spotted coat is the Bengal. The pattern on this cat's fur is particularly beautiful and makes it look a little like a wild cat.

Patched: This word is used to describe many different patterns, but it usually refers to random patches of color. Tortoiseshell, Calico, and bicolor cats have patched coats.

Ticked: Every hair in a ticked cat's coat features contrasting bands of light and dark color. From a distance, cats with this kind of marking look as if they're all one color. Upon closer inspection, however, a subtle pattern of banded color emerges. This pattern may be best described as having a subtle sand or graphite appearance.

Colorpoint: Siamese and Ragdoll cats have particularly beautiful markings. Overall, these cats are very light in color; the only color comes in the form of "colorpoints:" darker patches found on the ears, face, paws, tail, and nose.

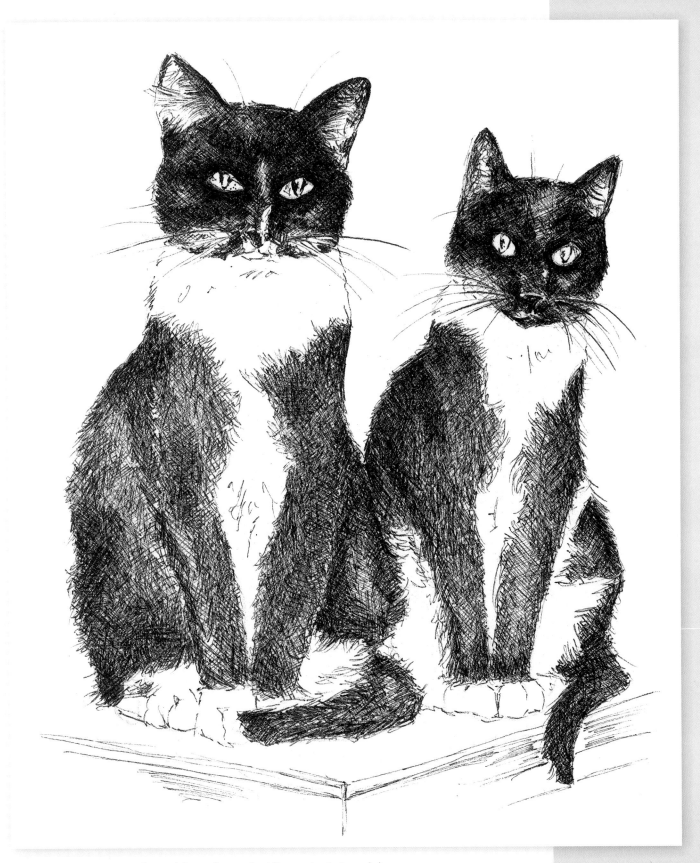

A common coat pattern is a white collar and white socks (a tuxedo).

God has
made the cat
to give man
the pleasure
of caressing
the tiger.

Victor Hugo

Color

The color of a cat's fur ranges from white to gray, beige, brown, red, and orange to black. These different shades form an eclectic color palette that can be found in any combination or pattern, including solid, bicolor, tricolor, tabby, or patched. Although cats come in a variety of colors, from a biological perspective, a cat's coat can only be made up of red and black. The different shades we see are down to the pigments in the cat's hair. White fur occurs because the hairs contain no color pigment at all.

Tip: Practice drawing different coat textures using simple lines and marks.

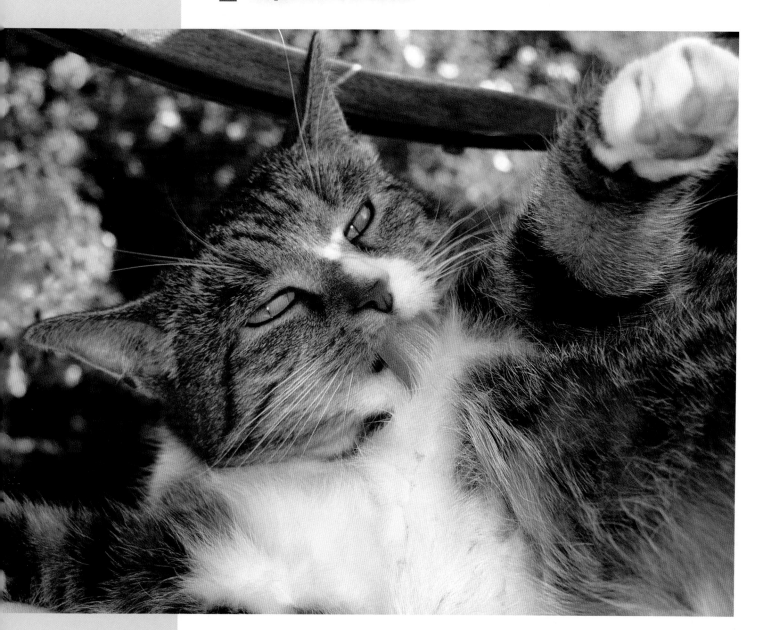

Cat fur often features a
diverse variety of color.
Pastels are a useful tool
for capturing these
unique color patterns.

Color & Texture: Exercise 1

Materials:
- *Drawing paper*
- *Pastels (chamois, light ochre, dark russet, black)*
- *Pastel pencils (black, ochre, russet, white)*
- *Blending stump*
- *Fixative spray*

Soft pastels can be combined to great effect with pastel pencils when drawing particular breeds. You can use the soft pastels to fill larger areas, which can then be worked with patterns or additional shades of color. You can then use pastel pencils to give the coat a more realistic texture and pattern. By working through this exercise step-by-step, you will familiarize yourself with the techniques needed for creating realistic fur texture.

Step 1
When using this technique, remember to work out the colors of the cat's coat first. Do this by examining the fur closely and choosing no more than four or five colors. Lay down a large area of color using the two lightest shades to reproduce the base color.

Step 2
Carefully smudge the soft pastel with your fingers. In more detailed areas, you can use a blending stump. Now turn your attention to the coat pattern. Before you start, work out exactly what the pattern is doing and what it looks like. Are there any patches? Are there any stripes? What direction do they run? Next, draw this pattern with your pastel or pastel pencil, making the color a shade darker each time. Apply the color lightly to begin with—you can always go back later and add more if you want.

Step 3

Blend the colors you have applied up to now with your fingers to create soft, smooth transitions and gradients of color. Now fix your picture with the fixative spray and let it dry before continuing. Next, continue adding the pattern with the black pencil. If the animal you want to draw doesn't have any black fur, simply use the same color as the darkest fur. Keep on drawing with your darkest shade and use a few strokes of pastel pencil to add a rough fur texture.

Step 4

Smudge the color once more with your finger or blending stump; then use the edge of the pastel or a charcoal or pastel pencil to continue adding texture. Pay attention to the direction the fur is growing in. Gently smudge the newly applied color and fix with the spray.

Step 5

Take the color you used most recently and draw the texture of the fur by adding additional strokes, working from the inside outward. Now change direction and work the other way around. You can either choose the same colors as before or use complementary colors.

Color & Texture: Exercise 2

Materials:
- *Drawing paper*
- *Pencil (HB)*
- *Soft pastels (chamois, light ochre, gold ochre, ochre, light umber, black)*
- *Pastel pencils (red shades: light, dark, sepia)*
- *White charcoal pencil*
- *Black charcoal pencil*
- *Blending stump*
- *Sharpener*
- *Kneaded eraser, pencil eraser*
- *Fixative spray*

Its leopard-like coat is what sets the Bengal apart from other breeds. Its head is round, and it also has large, round eyes, characterized by streaks at the sides of the eyelids. These streaks are also a feature of big cats. The medium-sized Bengal cat is a cross between the Asian leopard cat and the short-haired house cat. Its short, golden fur has a leopard-like pattern that can also be marbled in appearance. Its athletic and strong yet lean build is also a trait inherited from its wildcat ancestors.

Use the techniques on the previous pages to practice rendering the fur pattern of the Bengal.

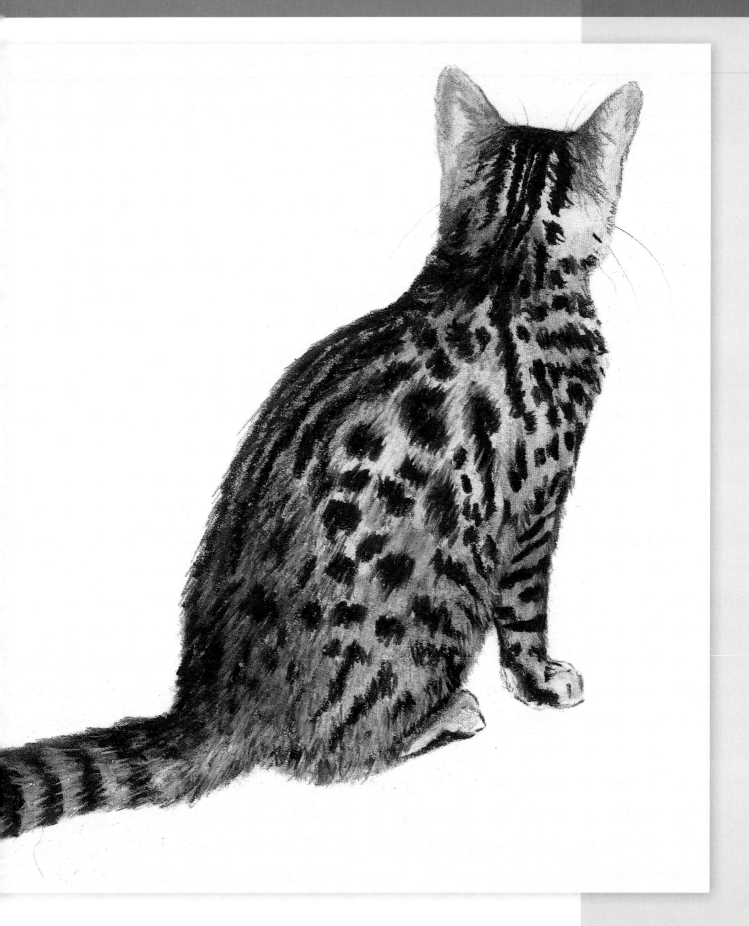

CHAPTER FOUR

MOVEMENT

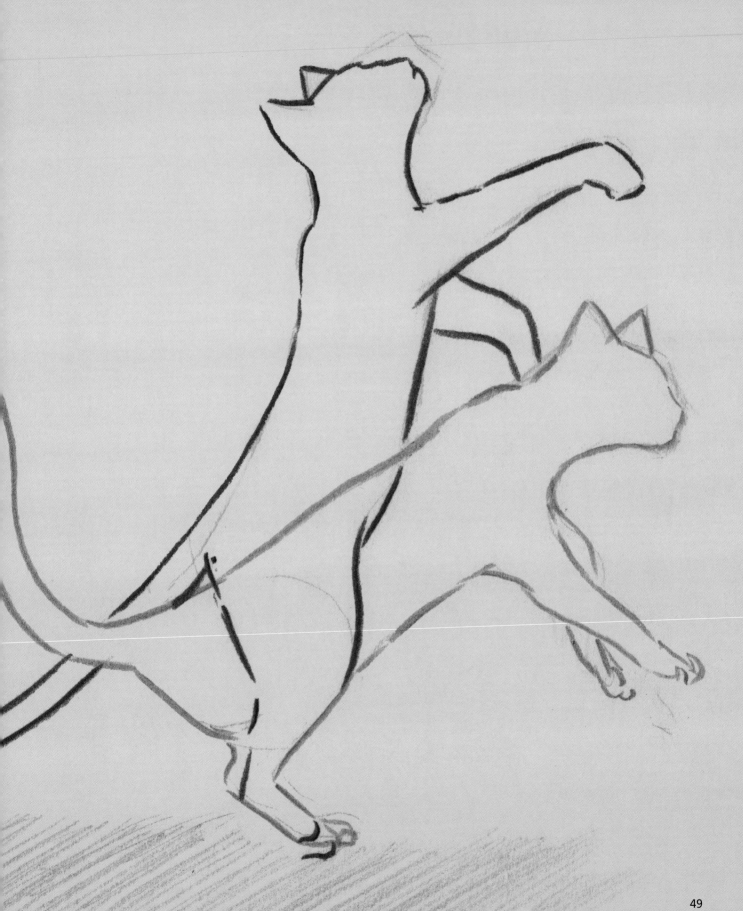

MOVEMENT

Movement studies are important in drawing. To get a feel for the anatomy and physiology of the cat, you should start off by drawing simple studies. Ideally, your own cat can serve as a model. Take your time observing the cat and then produce rough sketches of any movements it makes. Begin with simple poses, such as a sleeping or standing posture. Work with simple shapes, such as circles, triangles, and squares. The lines don't have to be precise. How your study looks is not the most important thing here either. In fact, it's quite alright for your lines to overlap. It will help if you draw each limb individually, just as you would when drawing from an articulated mannequin.

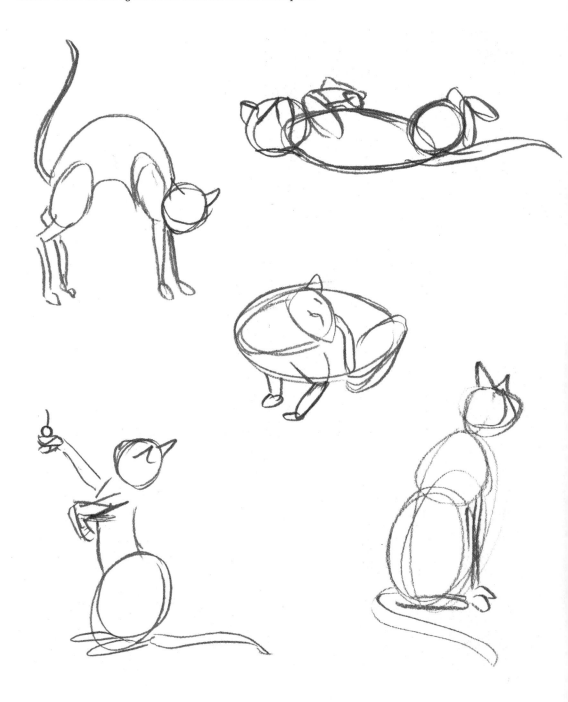

Start by sketching simple shapes, such as circles, triangles, and squares.

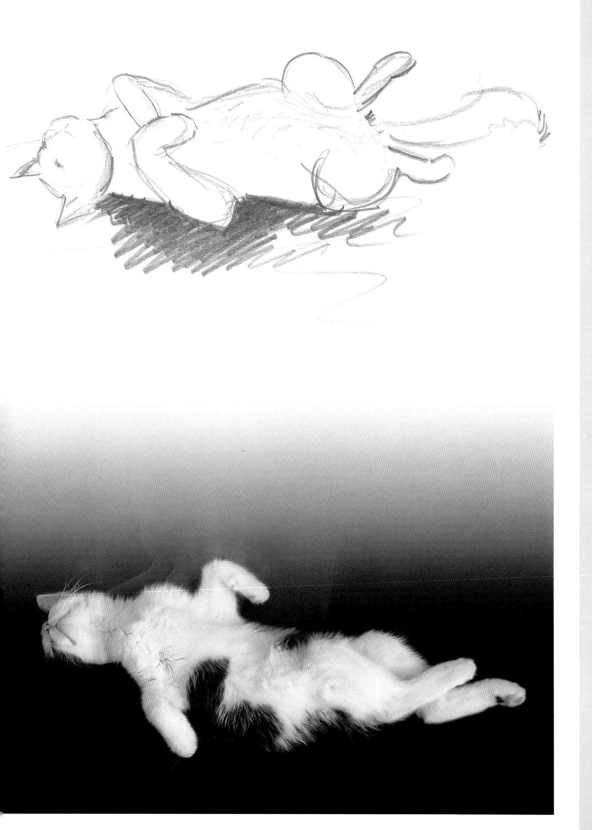

A cat is, in any posture, embodied grace. The sight of it alone is a delight.

Max Merten

A wanderer himself, he is full of reproaches if I am gone beyond the expected time.

Samantha Armstrong

If your movement sketch looks unnatural, keep on drawing, perhaps choosing a different perspective. Don't worry about the details here; focus solely on form. A graphite pencil is perfect for movement studies and rough sketches in particular. Just choose the hardness of pencil you're most comfortable with.

Slowly increase the complexity of your studies, gradually tackling more difficult postures. Keep working on them until you are happy with the result. With time, you'll become more confident in your skill.

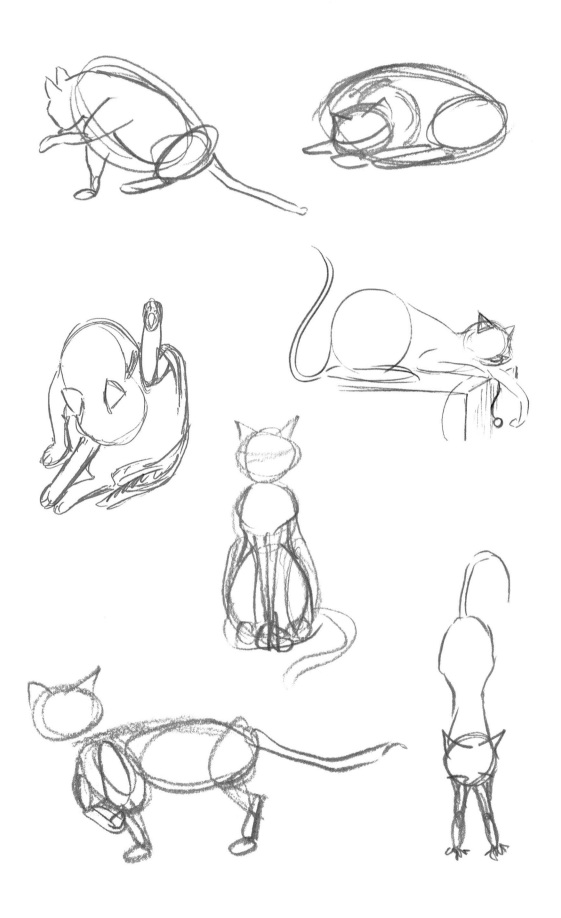

*In your movement
sketches, don't worry
about the details.
Simply concentrate
on form.*

Compiling a Sketchbook

A great way of recording your progress as an artist is to compile a book of your sketch studies. A small notebook can be taken with you wherever you go, so you can simply grab your pencil and get drawing whenever inspiration strikes. A larger sketchbook, on the other hand, can be used for more detailed drawings.

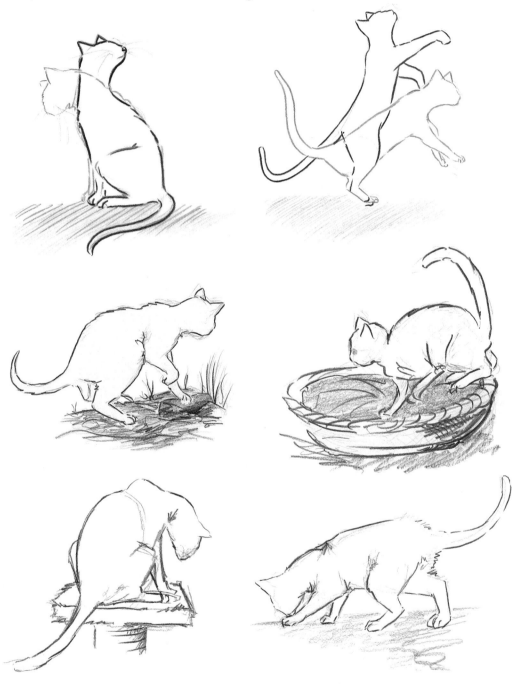

Tip: Observe a cat or compile a collection of photos (see page 107); then practice rendering the movements in just a few strokes and lines. Work the detail in more difficult areas.

Once you've gained confidence working in graphite pencil, use soft pastels in your movement studies to lay down large areas of color. Use pastel pencils to draw smaller, more detailed studies.

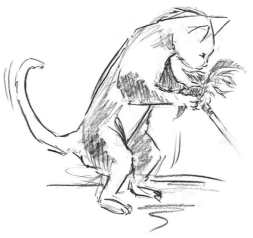

A book of your studies makes it easy to follow your progress as an artist.

CHAPTER FIVE

DRAWING TECHNIQUES

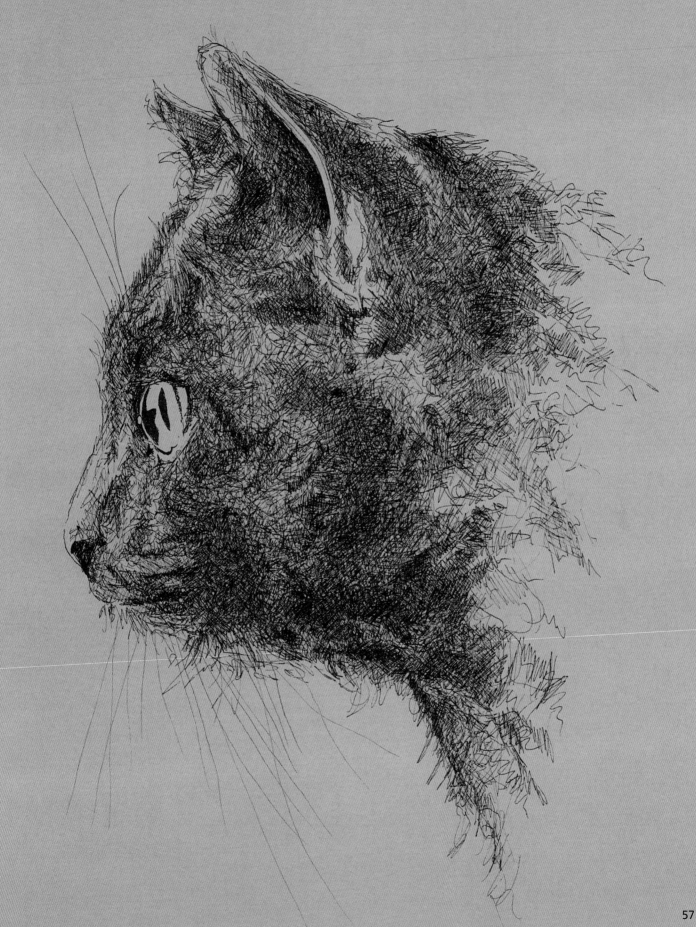

DRAWING TECHNIQUES

Sketching

As you've learned on the previous pages, sketching is used to capture an image quickly before fleshing it out with other techniques. A good sketch provides a solid start to a more polished piece. Often, the results are so beautiful that sketches are considered little works of art in their own right.

Shading

Shading is used to give drawings depth. Different techniques can be used when shading, but the most common is smooth shading, which is good for lead, charcoal, or graphite pencil drawings. In this technique, the pencil is held flat to the paper so the color is applied evenly.

Smooth shading

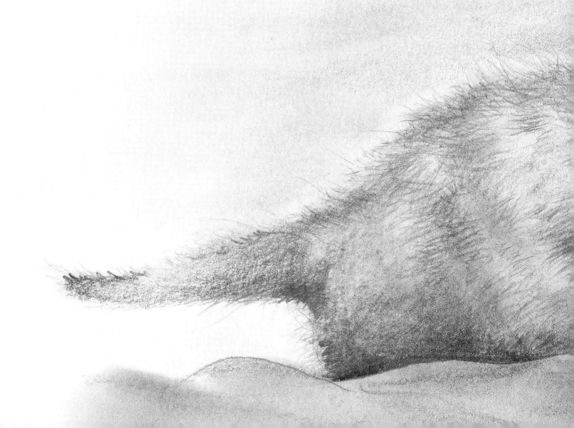

Hatching Techniques

Hatching means filling an area with parallel lines. This technique is often used with ink drawings or rough pencil sketches. Hatching can run in one direction only (horizontal, vertical, or diagonal) or in two or more different directions (crosshatching). More complex hatching patterns can run in every direction and can be used to achieve any degree of darkness. Scribble hatching in ink gives a drawing a dramatic, stylish character. The more densely the lines are placed beside or over one another, the more intense the effect becomes. The lines don't have to be straight; they can be drawn with curves, too. By shortening hatching lines as you approach lighter areas, you will create isolated areas with softer transitions.

Parallel hatching

Perpendicular hatching (crosshatching)

Quadruple crossing

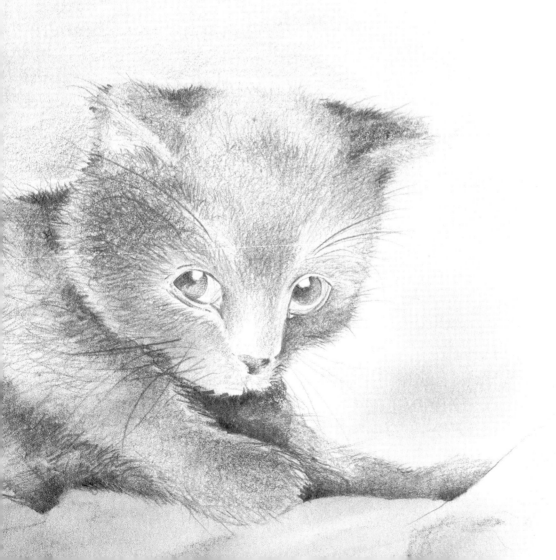

Stippling

Stippling

Stippling means reproducing a surface with dots or tiny points. These dots are often drawn using an ink pen. Stippling is a more sophisticated technique, and the result is utterly unique. The intensity of the shading depends on how close together the dots are drawn. The smaller the distance between each dot, the darker the surface will appear. The greater the distance between each individual dot, the lighter the surface will look.

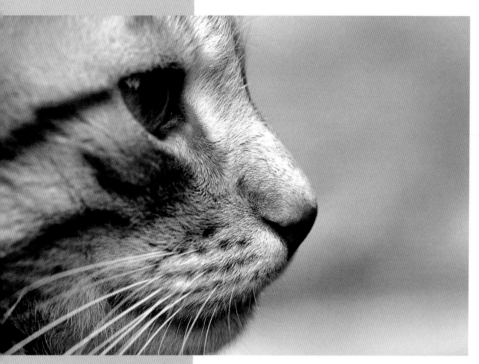

Wash technique

Wash Technique

Applying a wash over a drawing made with ink can add a soft, smooth effect. To create a wash on an ink drawing, load a thick paintbrush with a little water; then lightly drag the brush across the area. Dab lightly if the ink starts to run. Ideally, you should choose a watercolor paper that is suitable for ink drawings so that the paper doesn't buckle when you add a wash.

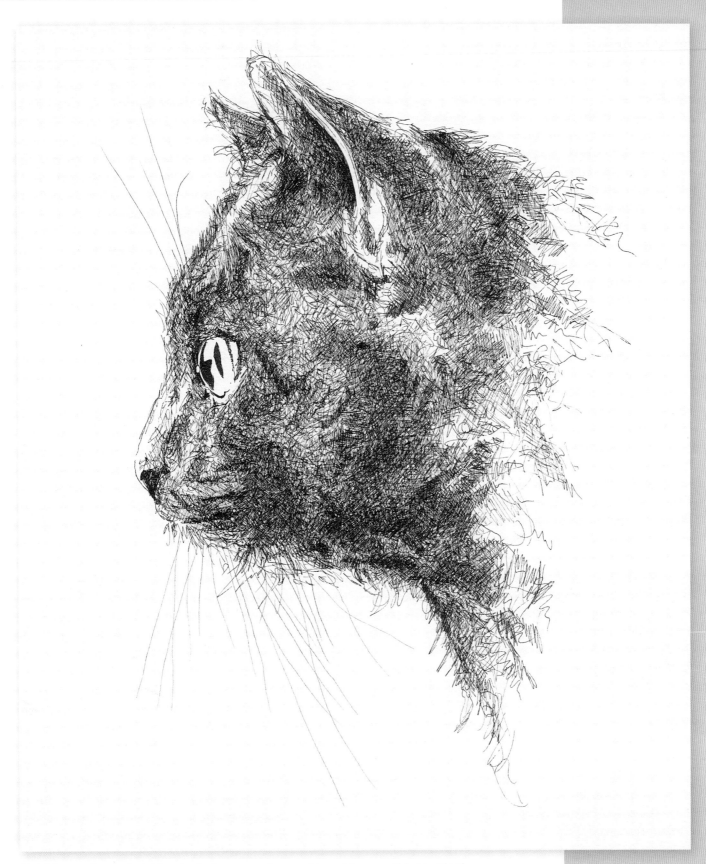

Hatching and crosshatching techniques can be used to achieve a wild, seemingly unstructured appearance.

Negative Drawing: Exercise

Materials:
- *Drawing paper*
- *Pencils (HB, 1B, 4B)*
- *Eraser*
- *Sharpener*

Step 1

In this exercise, the shape of the white cat is isolated and highlighted by the shading in the background, or the negative space. This is called a negative drawing technique. You can use subtle hatching and shading to make the white fur look realistic. First sketch the outline of the cat and the background with thin, delicate lines using an HB pencil and gentle pressure. Erase any excess lines, correcting them if you need to until you are happy with the result.

Step 2

With a slightly softer 1B pencil, roughly shade the plant, flowerpot, and shelf. The tip of the pencil should be slightly blunt so as to produce softer, wider lines. Go over these lines several times to create smooth shading that retains a little bit of texture. Don't work the outer contours of the cat in any more detail just yet.

Step 3

With your 4B, enhance the texture of the leaves, adding a few lines to separate the lighter and darker areas from one another. Because it's softer than the others, this pencil will get increasingly dull more quickly, so make sure that you sharpen it regularly.

Step 4

To lay down the lighter background, place the tip of the 1B on the outer contours of the cat's fur and draw long, thin lines that blend softly into the background. Repeat this step until your shading is practically seamless.

Step 5

Finally, work on the more intricate details of the cat's coat. Make sure your lines stay thin enough by sharpening your 1B pencil frequently while you work.

To give the coat an attractive texture, draw some scattered lines here and there to represent individual hairs. As you do this, pay attention to the direction the fur is growing. This technique can be used to emphasize the contours—in this case the neck and shoulders—without having to draw a hard contour line. When using the negative drawing technique, make sure you work the darker areas bordering the lighter areas in more detail first and finish by darkening areas where the light and dark sections meet.

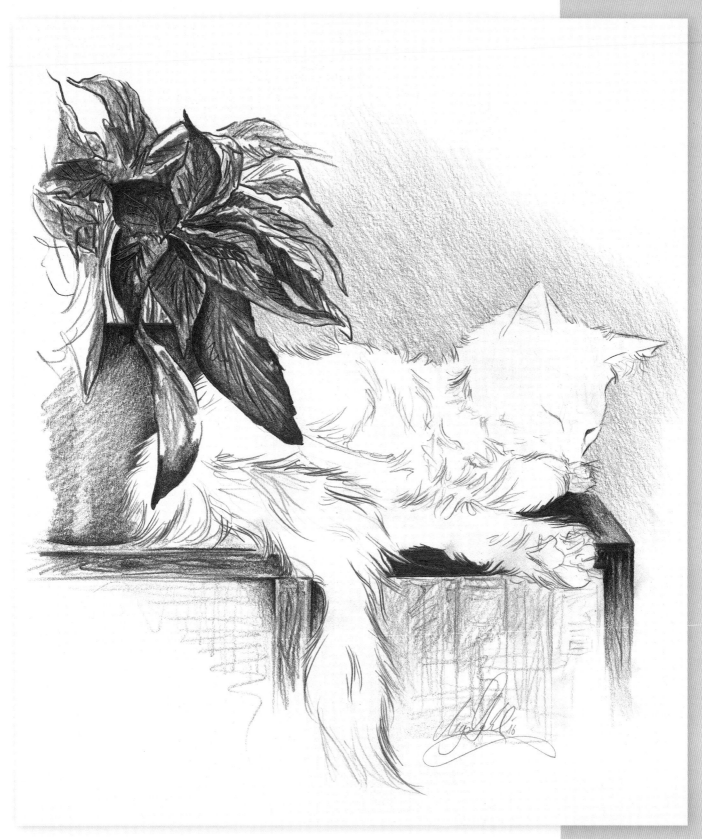

Start your drawing with delicate, thin lines that are easy to erase. That way, you can correct any mistakes you make.

Working with Basic Shapes

A complex drawing subject can be overwhelming for an artist. In these situations, it's helpful to approach it from an analytical perspective. Visualize the rough shapes of the cat's body, just as you would when producing a study or quick sketch. Think in terms of squares, rectangles, circles, and triangles. By doing this, you divide the cat into shapes and geometric spaces on a two-dimensional surface. The cat's body is usually oval or trapezoidal; the head, meanwhile, can be drawn as a circle and the ears as triangles. Other lines, such as the mouth, coat pattern, or the direction of the fur, can be added after the basic shapes are worked out. Draw the more complicated parts by gradually enlarging them and reproducing them in more detail. In these sections, you can use different hatching techniques to add shading and texture.

Start by sketching simple shapes such as circles, triangles, and squares. Then work each individual part of the cat step-by-step using different hatching, shading, and texturing techniques.

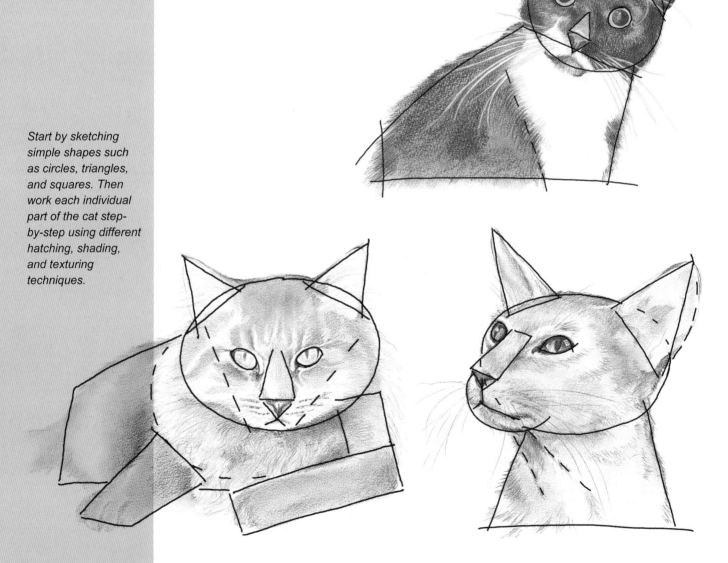

The Grid Method

This method helps you break down the subject into smaller, more manageable segments. First, photocopy your reference or a traced line drawing, and then draw a grid of squares (about 1 inch in size) over the photocopied image. Next, draw a corresponding grid over your drawing paper. Once you've created the grids, simply draw what you see in each square of the reference image in each square of the drawing paper. This method is ideal for transferring scenes from small reference photographs onto larger canvases.

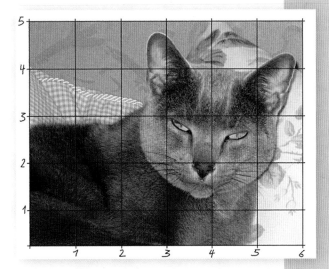

A grid made up of equally sized squares is drawn on transparency paper and placed on top of a photo.

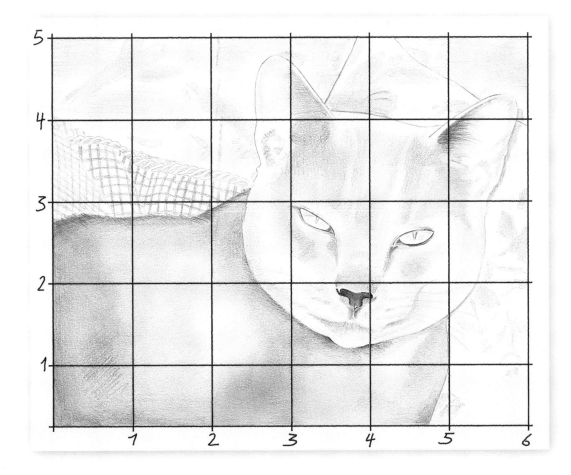

Combining Techniques

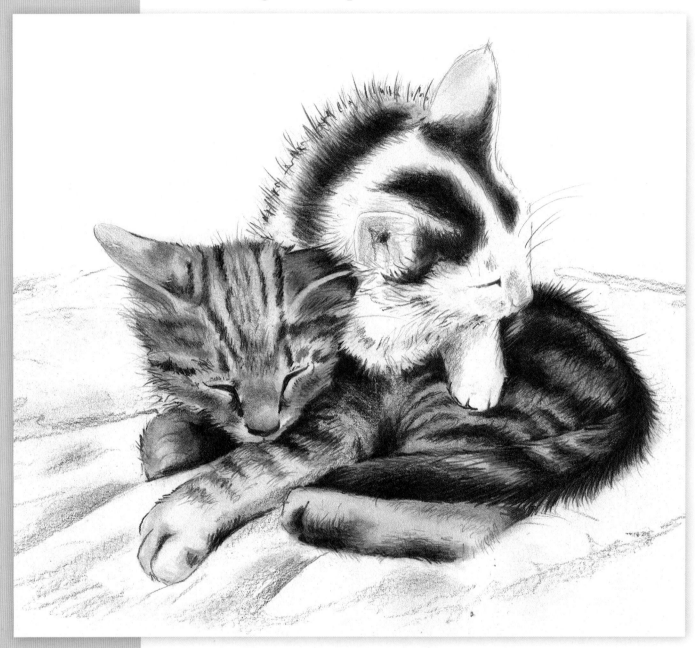

The example above uses hatching, combined with negative
and positive drawing techniques.

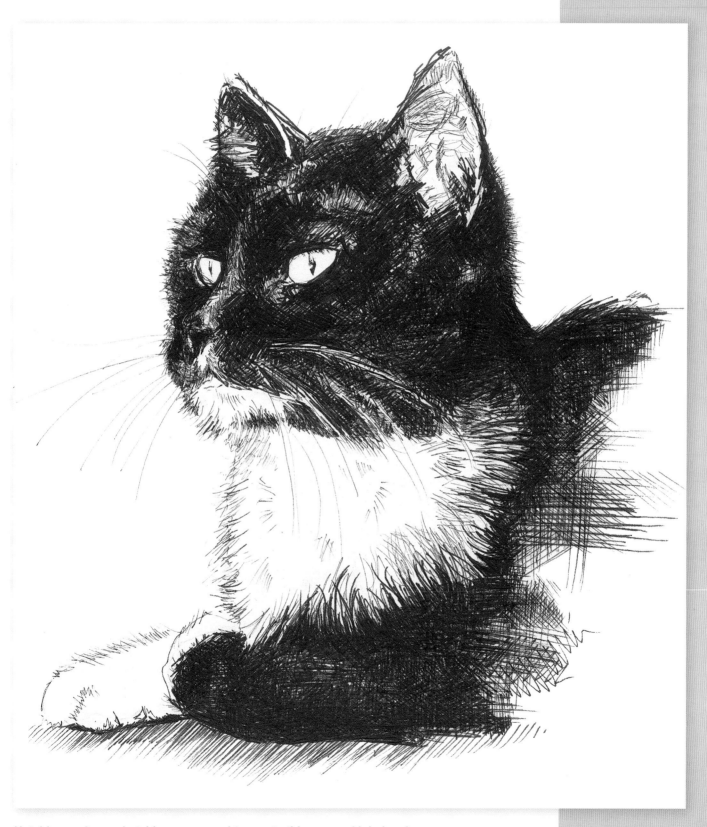

Hatching and crosshatching were used to create this pen and ink drawing.

CHAPTER SIX

STEP-BY-STEP PROJECTS

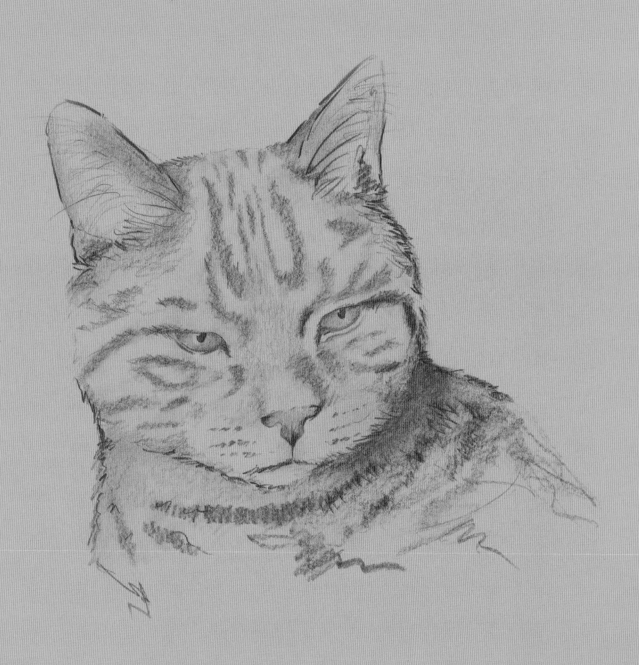

White Cat

Materials:
- ◆ *Black art paper*
- ◆ *Pencil (HB)*
- ◆ *White pastel pencil*
- ◆ *Charcoal pencil (unburned)*
- ◆ *Sharpener*
- ◆ *Kneaded eraser*
- ◆ *Fixative spray*

Step 1

With your HB pencil, lightly draw the contours of the cat on the black art paper. Erase excess lines with the kneaded eraser right away. Notice the cat's right front leg is in front of its left front leg. The cat's head is lowered, and its gaze is focused on the ball of wool. Only its right eye is visible. Place a blank sheet of paper under your drawing hand to prevent the white chalk from smudging.

Step 2

Trace over the outlines with the white pastel pencil. Make sure that your pencil is sharp, and keep sharpening it at regular intervals. Notice where the cat is in light and in shadow. Use your pastel pencil to create the highlights. Next, carefully smudge the shaded areas with your fingers until you have achieved a smooth, uniform gray tone. Use the eraser to clean up. Spray with fixing spray and allow to dry before continuing on to the next step.

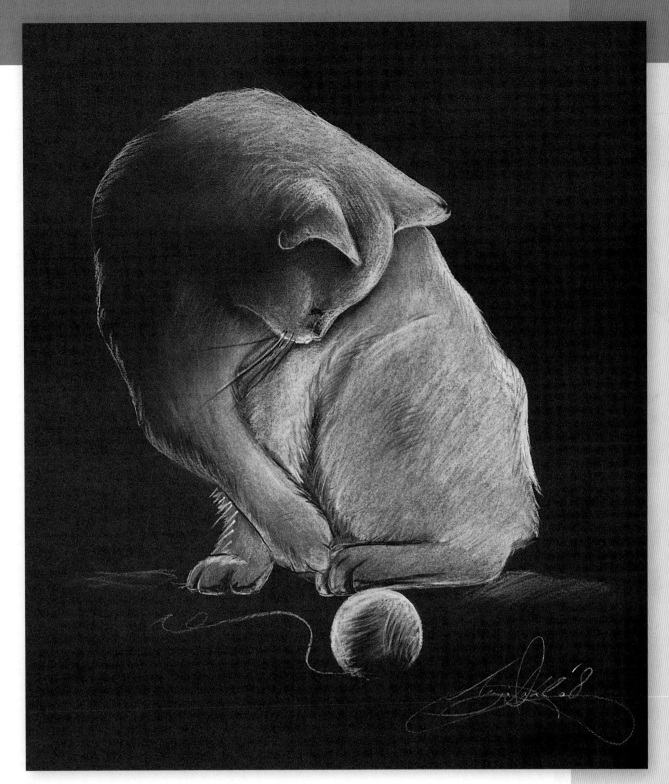

Step 3

Using the tip of the white pencil, work evenly across the gray areas adding lots of short lines to give the coat texture. Go over the outer contours once again and add more shading to them. Your aim is to create a smooth transition between the outline and the shading. Add some texture to the fur along the outline as well using several short, sweeping lines. Now take your charcoal pencil and use it to work over and enhance the edges of this texture and the parts of the coat that are in shadow. Once you've finished, use the kneaded eraser to rub out any excess marks. Spray the drawing with fixative and leave to dry.

Cat & Kittens

Materials:
- ◆ *Drawing paper*
- ◆ *Pastel pencil*
- ◆ *Charcoal pencil*
- ◆ *Sharpener*
- ◆ *Kneaded eraser*
- ◆ *Fixative spray*

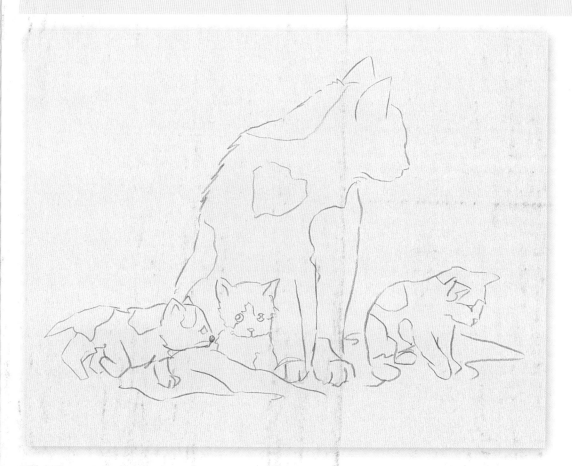

Step 1

Use the pastel pencil in a color of your choice to sketch the contours with sweeping lines. This drawing is sketch-like in style, which means that you don't have to add too many details. Because the pastel pencil is soft and wears down quickly, you will need to sharpen it often. The kittens have rounded bodies, their heads are still a little too big, and their proportions haven't settled down yet. Roughly sketch the patched patterns on their coats. Rough in a blanket beneath the feline family.

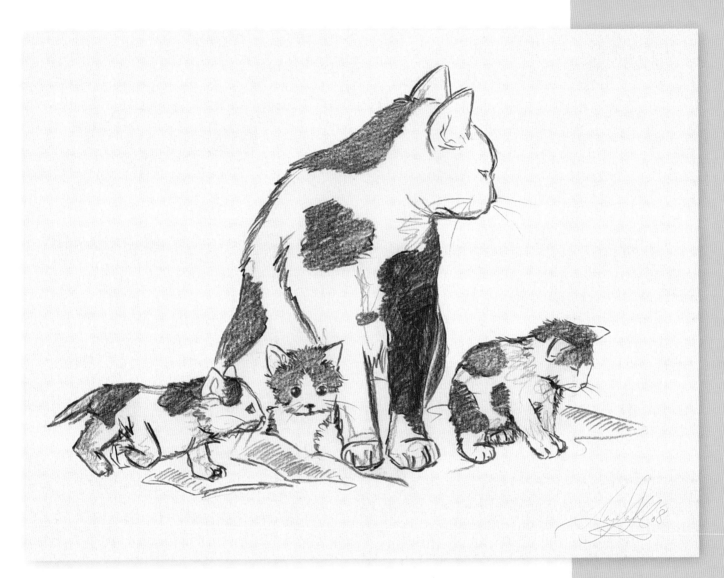

Step 2

Add color to the patches evenly with your pastel pencil. Add a little parallel hatching to the blanket. Now work over the entire drawing again to make it more vibrant. Next, use the black charcoal pencil to enhance several of the contours, such as the back of the mother's head and her paws, as well as the kittens' legs and heads. Lastly, spray with fixative and leave your picture to dry.

Sleeping Cats

The dog may be wonderful prose, but only the cat is poetry.

French proverb

Material:
◆ *Drawing paper*
◆ *Lead pencil (HB)*
◆ *Ink pen*
◆ *Black ink*
◆ *Kneaded eraser*

Step 1

With an HB pencil, lightly sketch these snuggling cats using small quick strokes. The ear of the cat shown on the left is depicted as an oval because this is what it looks like from the perspective of the observer. Add some small hairs to the inside of the ear and do the same with the cat on the right. The front legs of the cat on the right are not visible: Only one of its hind legs can be seen in the foreground.

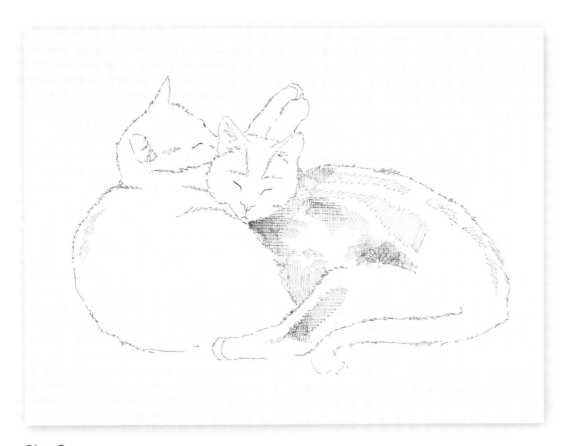

Step 2

Use an ink pen to trace over the outer contours of the cats. The lines you draw should be irregular and jagged to imitate the texture of the coat. If any pencil lines are still showing through, rub them out with the kneaded eraser until they're only slightly visible. Carefully draw two half triangles on the face of the cat on the right. The lines of the triangle should run from the ear to the forehead. Begin adding hatching and crosshatching to the cat on the right.

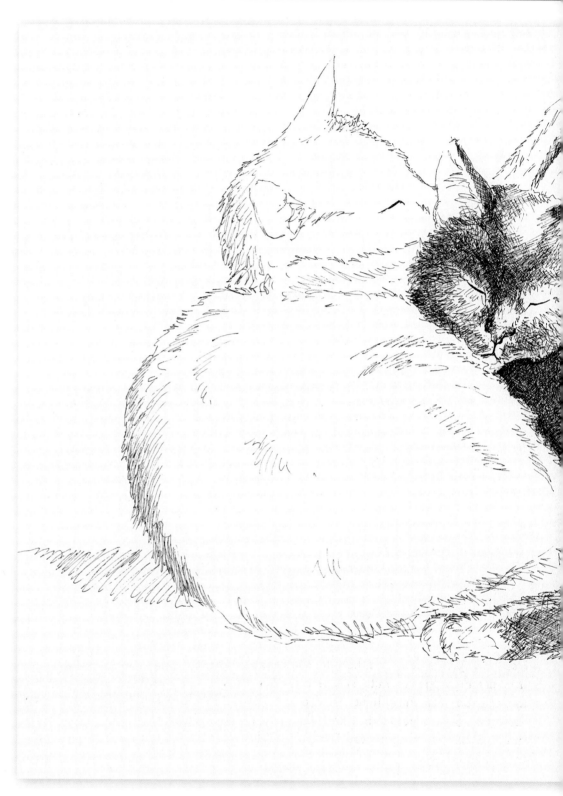

Step 3

Continue to use hatching and crosshatching until the desired depth is reached. Add some loose parallel hatching to the back of the cats' heads. Then add a little bit of ground using a few loose strokes.

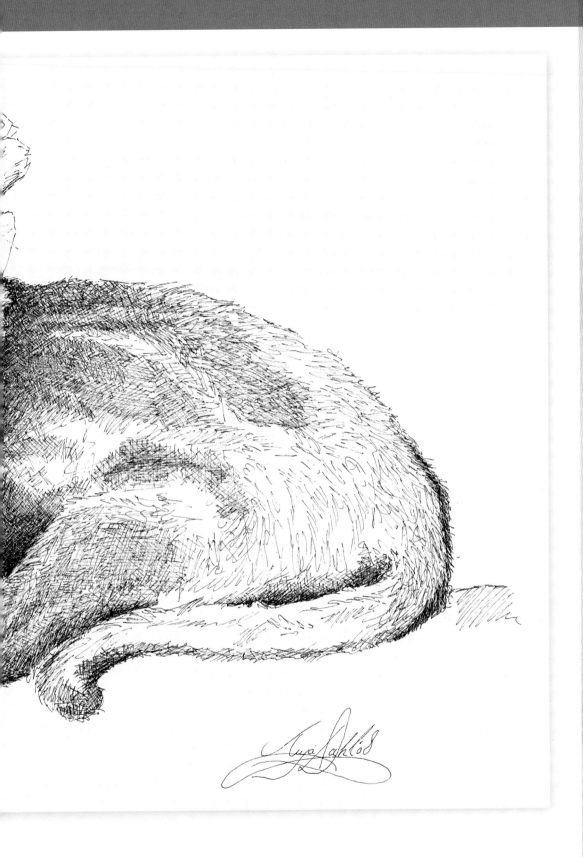

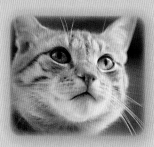

A cat is only technically an animal, being divine.

Robert Lynd

Mackerel Tabby

Materials:
◆ *Drawing paper*
◆ *Pencil (HB)*
◆ *Pastel pencils (light and dark in monochromatic colors)*
◆ *Blending stump*
◆ *Kneaded eraser*
◆ *Fixative spray*

Step 1
Lightly sketch the outlines of the cat with the HB pencil. Include the pattern on the facial fur in your sketch, but don't press the pencil into the paper too hard.

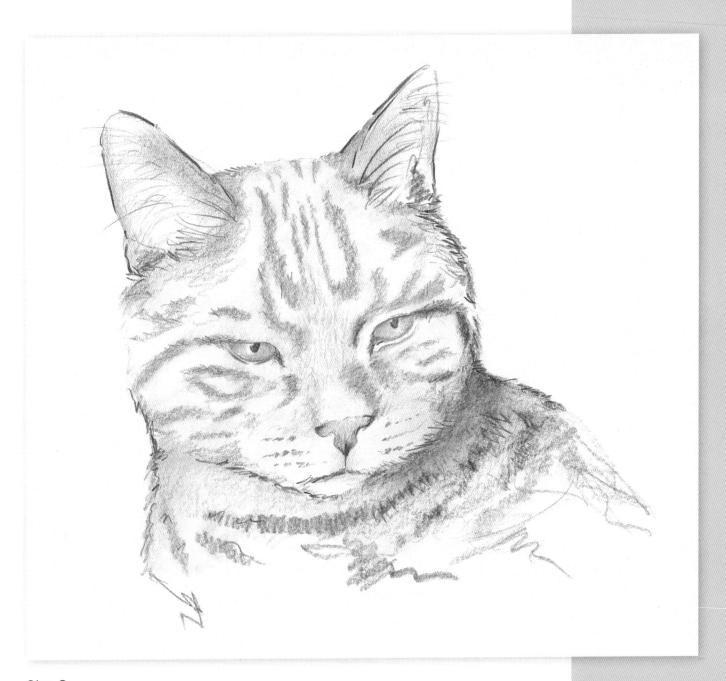

Step 2

Trace over the pencil lines with your dark pastel pencil, concentrating on one small area of the drawing at a time. Reproduce the tabby pattern on the face using broken lines. With the lighter-colored pencil, work the smaller areas. Next blend the entire drawing with the stump to give the light areas some tone. Finally, spray your drawing with fixative.

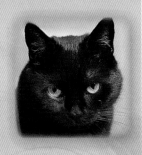

Black Cat

Material:
- *Drawing paper*
- *Lead pencils (HB, 2B, 5B)*
- *Sharpener*
- *Kneaded eraser*
- *Fixative spray*

Step 1

Roughly sketch the cat's head onto your drawing paper with the HB pencil using loose lines. Make sure that the ears and eyes are as symmetrical as possible. Rub out any unwanted lines with the kneaded eraser and refine any other lines until you're happy with your sketch. Make sure that the head is triangular in shape. The cat is looking up, so the pupils should be against the upper edge of the eyelid. The chin is not very prominent, and the nose is elongated.

Step 2

Use the 5B pencil to begin shading the face. Blend these areas with your fingers until the pencil lines are no longer visible. Be particularly careful when working around the forehead and the eyes. Use light pressure when applying the hatching so that none of the lines look darker than any of the others. Continue to smooth over the areas around the lines to achieve even tone.

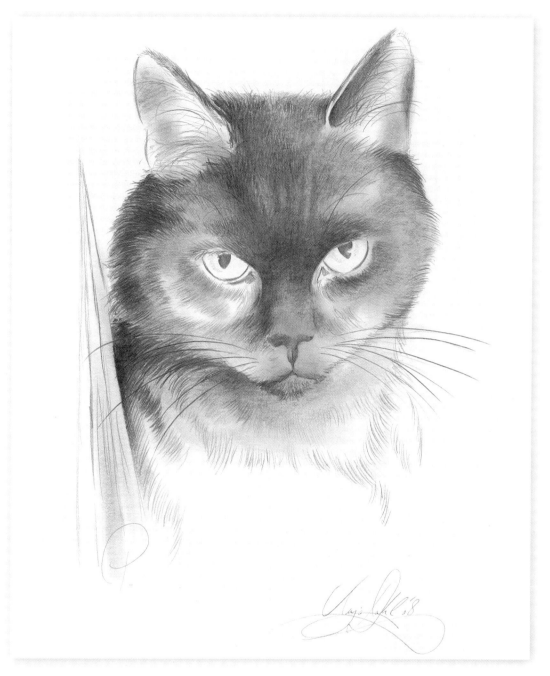

Step 3

Use a 2B pencil to add texture to the face and neck. This pencil is darker than an HB but not as soft as a 5B. As you add more detail to create fur texture, keep sharpening the tip of the pencil. Finally, add the whiskers using large sweeping strokes.

CHAPTER SEVEN

SPECIFIC BREEDS

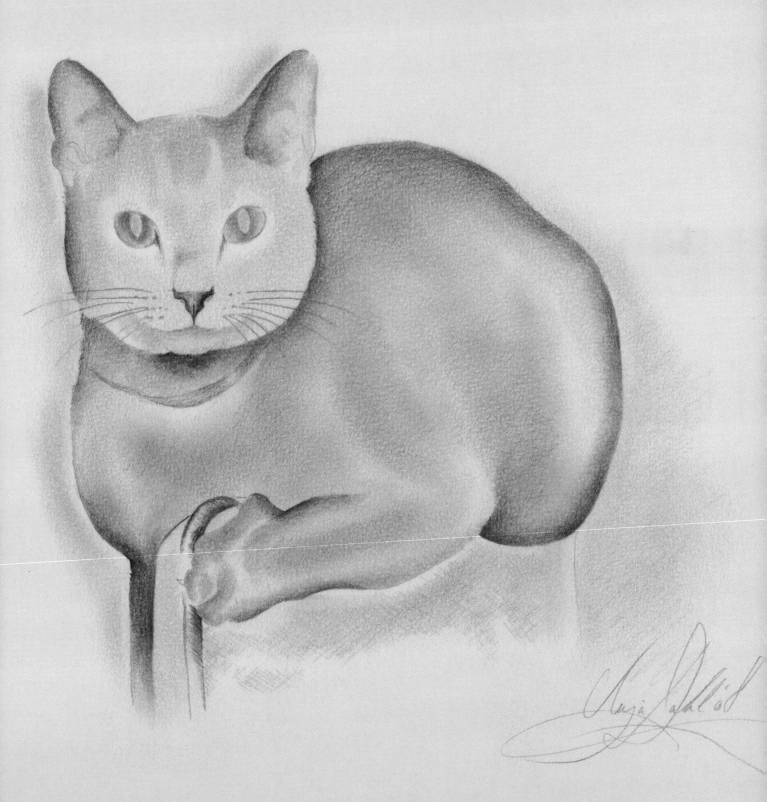

DRAWING SPECIFIC BREEDS

Popular Breeds

Shorthairs

The American Shorthair, British Shorthair, and European Shorthair are all terms used to refer to the common house cat. These cats come in all colors and patterns, from colorful tabby to red mackerel. Their physical characteristics are just as varied: the head can be round, square, or triangular, and the body can be round, long, or muscular. Their eyes are round or a subtle almond shape.

Norwegian Forest Cat

There is one key difference between the Norwegian Forest Cat and the similar Maine Coon: the Norwegian Forest Cat has a more robust build. It has thicker fur and is also slightly larger than the Maine Coon. Its eyes are large and round, and its nose is relatively broad. The Norwegian Forest Cat's head is triangular, and the chin is slightly square. It sports an impressive collar of fur around its neck. The hind legs are longer than the front legs. The little sections of fur between its toes are especially interesting: in the wild, these would have helped the cat run across the snow. The fur comes in all patterns and colors, from snow-white to mackerel and tabby.

Persian

The Persian is a long-haired cat. The contours of the Persian's body are mostly covered by its long, dense fur. Its high cheeks and little snub noses give it a compact-looking face. The Persian's ears are rounded and often completely concealed by the long fur. Its fur also makes its dainty legs look wider than they actually are. To get a good result when drawing a Persian, pay attention to the direction of the fur. Sweeping lines, interspersed with broken lines, can be used to create a beautiful coat texture.

Russian Blue

The Russian Blue, as its name suggests, has its roots in Russia and is sometimes confused with the Chartreux. Stroke a Russian Blue and you will feel a double coat, which is completely unique to this particular breed. Its silvery gray-blue fur is short and velvety. Its characteristic emerald-green eyes are big and round, sometimes almond-shaped. The Russian Blue is born with blue eyes, which change to a vibrant green during the first year of life. It is robust and muscular yet slender in build.

Chartreux

With its blue-gray fur and golden eyes, the Chartreux has an almost mystical charm. This cat comes from France, which is where it gets its name. The large, round eyes give the cat a soft, friendly expression that reflects its gentle character. The Chartreux has a robust, large build and broad shoulders. Its neck is strong and thick. Its head is round with full cheeks, and its nose is straight and broad. The ears are small- to medium-sized and placed high on the head. They are straight and narrow at the base and slightly rounded at the tip. This cat's fur is dense and thick. It comes in all shades of gray, from light gray to blue-gray, and it has a velvety sheen.

Siamese

The Siamese's timeless elegance makes it one of the world's most popular breeds. Its unusual, refined appearance is not just down to its athletic, slim build—the dark points it has on its ears, face, feet, and tail are white at birth and turn dark over the first few months of life. This coloring can be more striking in outdoor cats than in indoor cats as it appears on the coldest parts of the body. The Siamese's distinctive triangular head is made even more so by its large ears. The facial fur is also dark. The Siamese's eyes are almond-shaped, medium-sized, and a beautiful shade of blue.

Siamese

Materials:
◆ *Drawing paper*
◆ *Pencils (HB, 3B)*
◆ *Kneaded eraser*
◆ *Fixative spray*

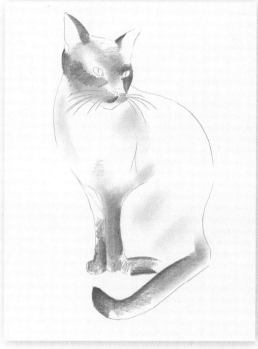

Step 1

Sketch an outline of the Siamese cat with an HB pencil. The lines should be clear and flowing. The cat's fine features are graceful and even. Sketch the eyes, which are relatively small compared to the face. The pupils are narrow and little more than thin dashes.

Step 2

Use your HB pencil to roughly shade the face, blending the area with your fingers. Shade the front legs, hind paws, and tail, blending them as well. Carefully lay down the first areas of light-gray shading on the body. Make sure that the shading is smooth and that there are no streaks. Use a kneaded eraser to carefully dab out excess lines. Blend again with clean fingers.

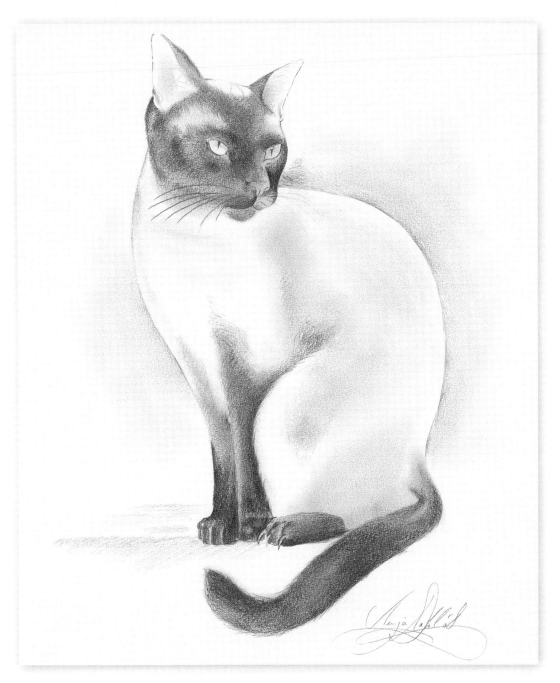

Step 3

Continue developing the shape of the cat's body by working on the light areas of shading and extending them across the back. Then darken the areas on the face, legs, and tail by drawing the light texture of fur over the shading. To ensure that the front and hind legs don't merge into one another, shade the front leg slightly darker. Shade the eyes lightly so they don't look flat. Leave a small reflection of light in the right pupil. Now carefully shade the background to the left and right of the cat and blend these areas carefully. Finally, emphasize the ground beneath the cat's paws.

Forest Cat

Materials:
◆ *Drawing paper*
◆ *Pencil (HB)*
◆ *Charcoal pencil (burned and unburned)*
◆ *White pastel pencil*
◆ *Sharpener or sandpaper*
◆ *Blending stump*
◆ *Kneaded eraser*
◆ *Fixative spray*

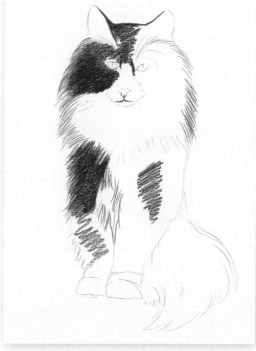

Step 1

Sketch the basic lines of the Forest Cat with an HB pencil using clear, flowing lines. The face is an even color and can be reproduced with a few simple shapes. Lightly sketch the eyes with thin lines. As in the drawing of the Siamese, the pupils should be narrow and little more than thin dashes.

Step 2

Trace with a blunt charcoal pencil over the fur along the outside edges. Draw the lines for the mouth and whiskers. Use the unburned charcoal pencil and fill all areas up to the muzzle, collar, and tail. Now blend these areas with your fingers. Use the blending stump for small or transitional areas. Leave a little space at the eyes to avoid the risk of going over the edge or smudging it. This small gap can then be colored in neatly with the unburned charcoal pencil. Carefully spray the drawing with fixative and let it dry before continuing.

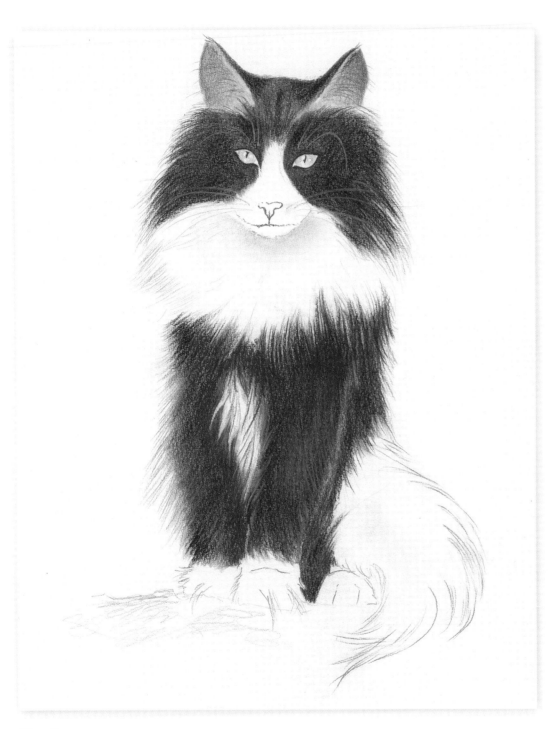

Step 3

Use the white pastel pencil to work the texture of the fur and whiskers. Keep sharpening the pencil as you work so that your lines don't become too thick. Shade the tops of the irises with the HB pencil, leaving the reflections of light white. Finally contour the ground beneath the paws with several loose pencil strokes.

*A cat's eyes are
windows enabling
us to see into
another world.*

Irish saying

European Shorthair

Materials:
◆ *Drawing paper*
◆ *Pencils (HB, 3B)*
◆ *Blending stump*
◆ *Kneaded eraser*
◆ *Fixative spray*

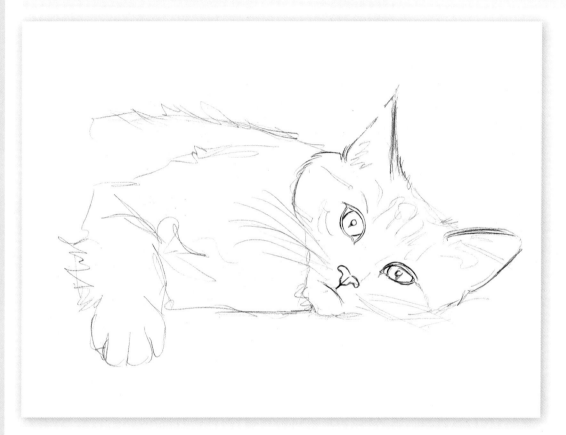

Step 1

Lightly sketch the outlines with an HB pencil. Make sure that you don't press down into the paper too firmly. The cat is lying on the side of its face, so the face will not be symmetrical. The right eye is slightly smaller and the right ear is a little larger. The nose has a clear, delicate shape, and the mouth is very narrow. The cat's back is not defined by a clear line; instead, it runs irregularly through the soft, fluffy fur. Use loose strokes to work out these sections.

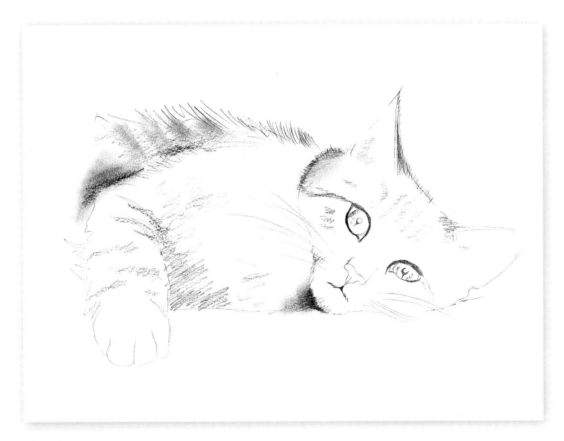

Step 2

Now draw the tabby pattern on the cat's face using soft, broken lines. Carefully work all the darker areas around the eyes, leaving the soft points of light in the pupils white. Enhance the shape of the nose with a little bit of shading along the inside. Accentuate the cat's chin with a few small strokes of pencil, and add shading to the shadowed area beneath it. Now add hatching to create the tabby pattern on the back, leg, and chest. Blend this lightly with your fingers.

Step 3

Add further emphasis to the hatching on the tabby pattern to create more texture. To make the fur look soft and fluffy, blend the area carefully with your fingers. Drag the kneaded eraser across the drawing in long strokes, following the direction of the tabby pattern. This will make sections of it lighter. Darken the bottom of the chest with the 3B pencil, as well as under the chin and behind the front leg. Finally, lightly contour the ground beneath the cat.

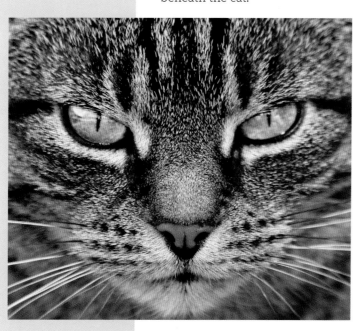

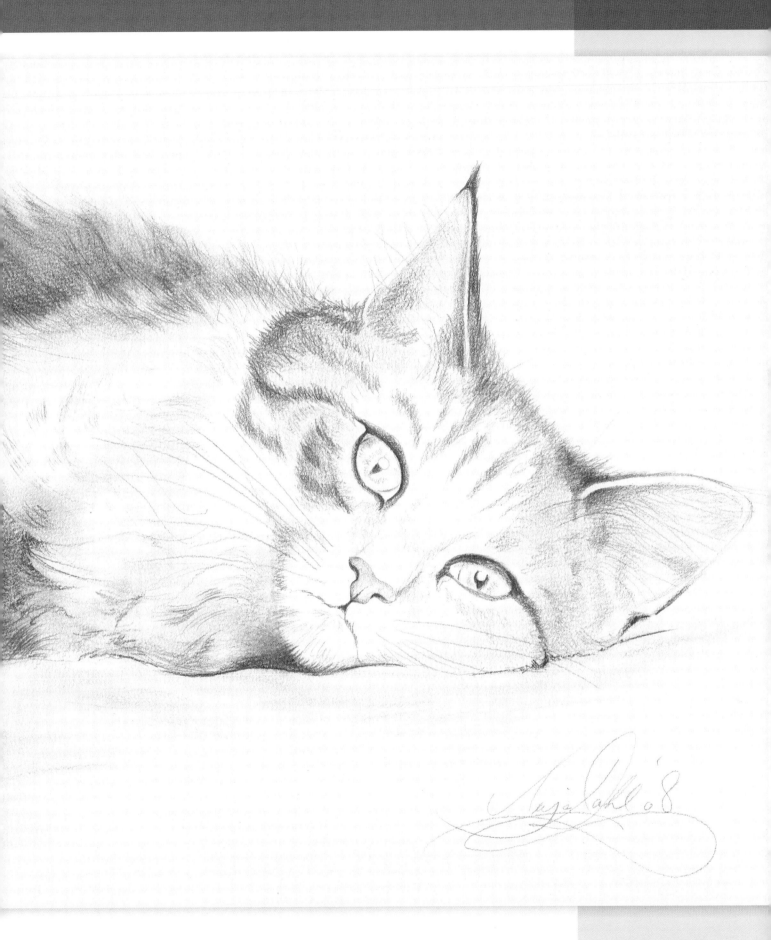

The ideal of calm exists in a sitting cat.

Jules Renard

Orange Tabby

Materials:

- ◆ Beige drawing paper
- ◆ Pastel pencil (red shade of your choice)
- ◆ Sharpener
- ◆ Kneaded eraser
- ◆ Fixative spray

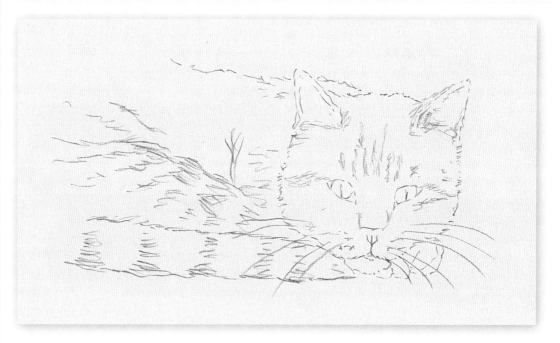

Step 1

Draw the basic outlines with short strokes using a sharpened pastel pencil. Press gently on the paper as you draw. Include the pattern on the cat's face in your sketch. Pay particular attention to the eyes, nose, and mouth. Add the delicate whiskers. Re-sharpen the pencil at regular intervals so that your lines stay fine and thin.

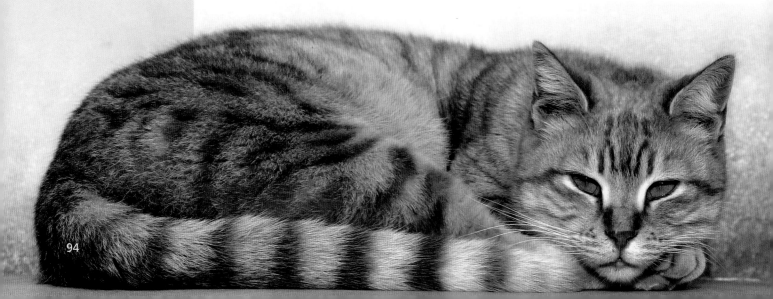

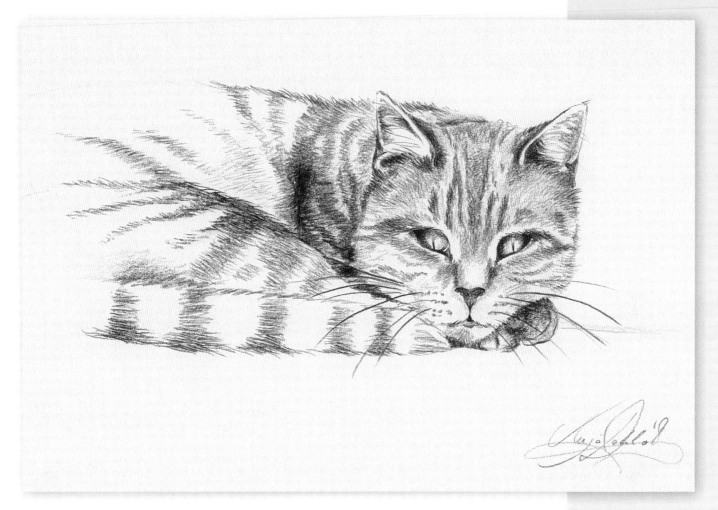

Step 2

Now shade the area between the eyes, below the ears, and to the left and right of the nose, keeping your aim for a light red shade. Lay down some texture on the coat using lots of small strokes. Carefully fill the eyes and darken them at the corners. Use a thin stroke of red to reproduce the pupils, making it a little darker at the bottom. Use small strokes to fill and enhance the pattern on the head. Sketch the contours of the back with small strokes. Darken the area beside the cat's head by adding deeper shading. Use a sharpened pencil to draw the pattern on the cat's tail. The lines representing each individual hair here will be much longer than the rest of the coat. Spray your drawing with fixative to finish.

Russian Blue

Materials:
- ◆ *Drawing paper*
- ◆ *Pastel pencils (grass green, olive green, dark green)*
- ◆ *Pencil (HB)*
- ◆ *Blending stump*
- ◆ *Kneaded eraser*
- ◆ *Fixative spray*

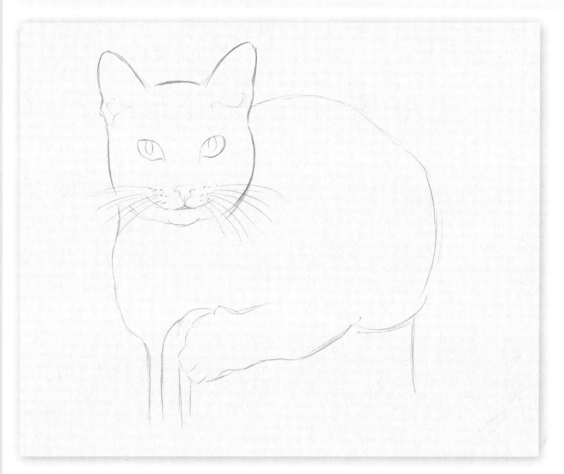

Step 1

With an HB pencil, carefully draw the outline with thin, delicate strokes. The Russian Blue's features are round and pronounced. We will not add coat texture in this practice drawing, so the lines do not have to include hatching. Draw the cat's irises with a sharp pencil, keeping your lines as thin as possible.

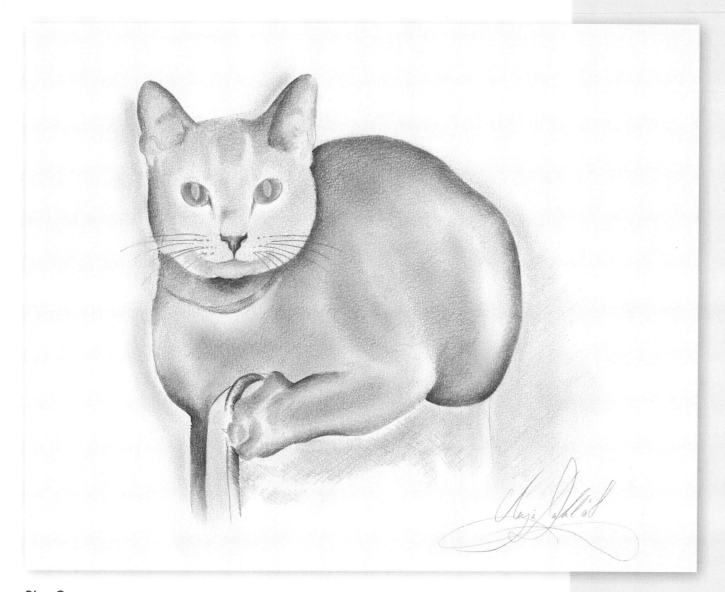

Step 2

Now lay down large areas of shading with the HB pencil. Hold the tip of the pencil at a flat angle to avoid hard lines. Carefully smudge the shaded areas with your fingers. Make sure that the shading isn't patchy and that no pencil strokes are visible. Shade the outer contours very lightly with the HB pencil, and then smudge them carefully with the blending stump. Add some color to the eyes with a green pastel pencil. The pupils should also be filled with green. Use the dark green or olive green for the iris. Then blend the eyes carefully with the stump to create even tone. Darken some areas of the picture, such as the front leg, and add some texture to the fabric on the stool. Finally lay down some light shading on the background behind the cat; then blend this carefully with your fingers.

Norwegian Forest Cat

Materials:
◆ *Drawing paper*
◆ *Pencil (HB)*
◆ *Blending stump*
◆ *Kneaded eraser*
◆ *Fixative spray*

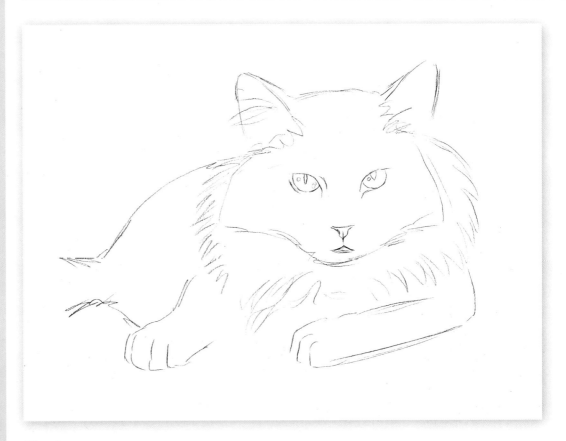

Step 1
Lightly sketch the outline using an HB pencil. The shape of the head is defined by the sections of fur on either side of the face. Sketch this collar of fur in quick, short strokes. Draw the two front legs with simple lines.

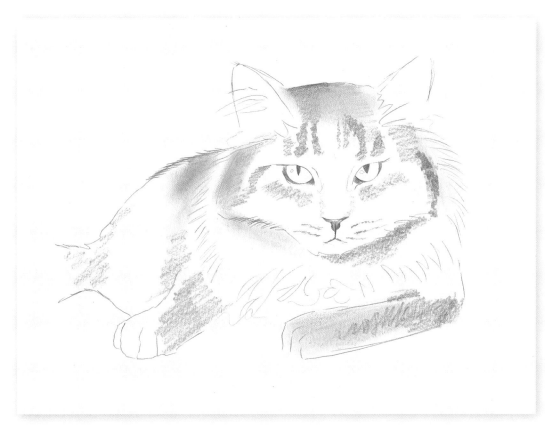

Step 2

Now lay down large areas of shading on the body and legs with the HB pencil. Apply gentle
pressure and hold the pencil at a flat angle. Next, shade the first section of tabby pattern on
the face. Then carefully blend all shaded areas with your fingers for a clean, even texture.
Go over the tabby pattern on the face again with an HB pencil. Blend using the stump this
time rather than your fingers.

Step 3

Continue shading the head and body, darkening it at the top, under the chin, and around the outside of the ears to add depth. Work the shape of the eyes with darker areas, leaving the points of light in the irises. Enhance the shape of the nose with a little bit of shading and create the texture of the fur by working over with short strokes. Continue applying the patterns to the forehead, the areas beneath the eyes, and the cheeks. Draw the base of the whiskers, chin, and mouth with small, short strokes. Use thin, fine lines to draw the delicate hairs in the ears and whiskers. Use light pressure so that there are no visible joins. The Norwegian Forest Cat's characteristic fur collar can be filled out with a blunt HB pencil and irregular strokes for the fur around the collar. Trace around the outline using small strokes to give the impression of individual hairs. Spray your work with fixative.

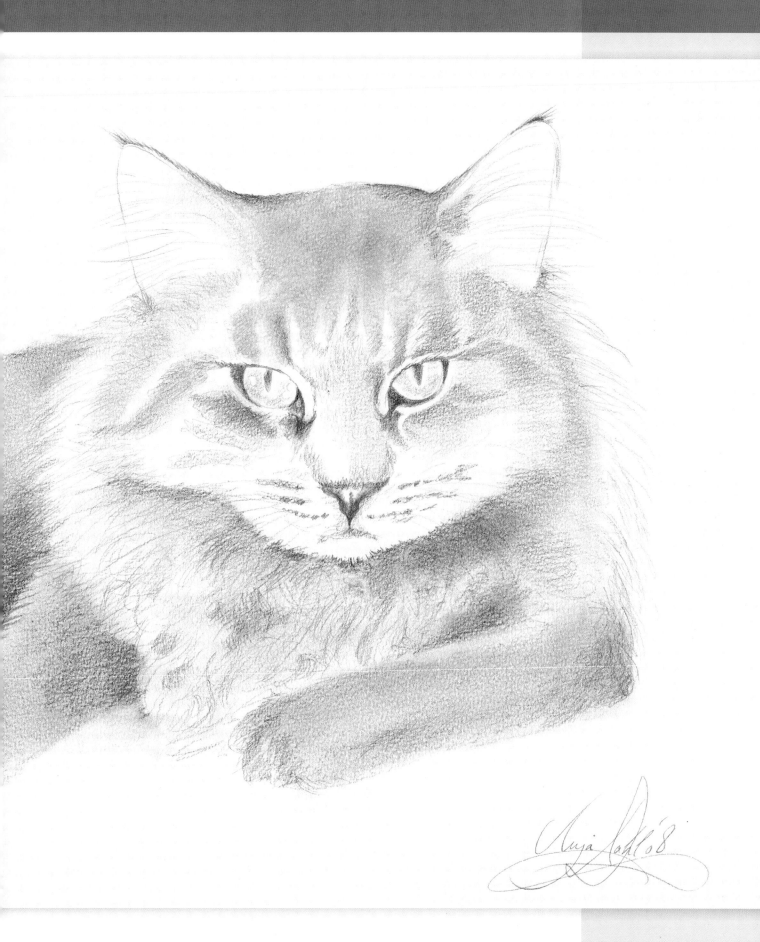

Bengal Kitten

Materials:
- *Drawing paper*
- *Pencil (HB)*
- *Soft pastels (chamois, light ochre, gold ochre, ochre, light umber, black)*
- *Pastel pencils (red shades: light, dark, and sepia)*
- *Pastel pencils (white, gray)*
- *Black charcoal pencil*
- *Blending stump*
- *Sharpener*
- *Kneaded eraser, pencil eraser*
- *Fixative spray*

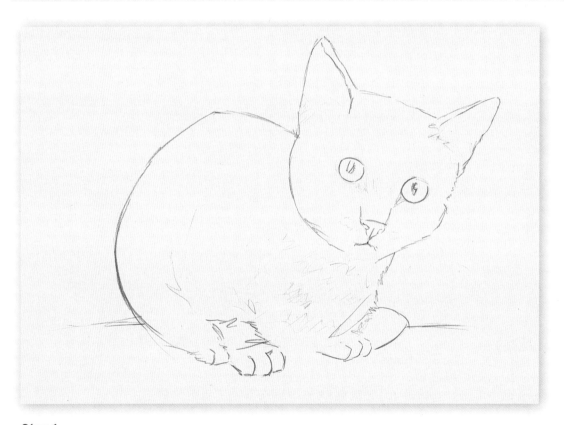

Step 1
Sketch the cat's silhouette; then start with the eyes. This requires a bit of care, as placing the eyes in the correct position will make all the steps that follow a lot easier. Pay attention to the distance between each line.

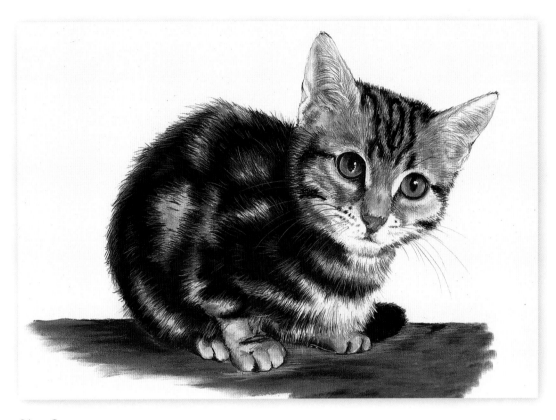

Step 2

Now trace over the lines more heavily with the light red pastel pencil. Place a sheet of paper under your hand to stop from smudging any lines you have drawn so far. Begin, once more, with the eyes. Work the edges with the light red pencil, and then use a gray pastel pencil and a black charcoal pencil for the pupils. Make sure that you add reflections of light to the cat's eye. Refer back to the tutorials on pages 44–47 as you begin to work on the coat. Draw the pattern onto the coat with the light red pencil. Pay attention to which parts of the cat have light fur and which have darker fur. Apply color with your pastels, and then carefully blend with your fingers. Use a blending stump on more detailed areas. Continue to build up the pattern in layers; then blend as needed. Fix your picture with a fixative spray and leave it to dry before you continue. Add more texture to the coat with the red soft pastel and pastel pencils. Reproduce the texture of the fur with delicate strokes in the direction of fur growth. Work the edges of the pattern with each different pencil in turn to create colorful areas with flowing transitions. Fix your drawing.

Maine Coon

Materials:
◆ *Drawing paper*
◆ *Pencils (HB, 4B)*
◆ *Kneaded eraser*
◆ *Sharpener*

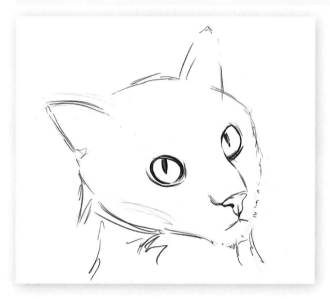

Step 1

Sketch the outline with the HB pencil using light-gray lines, paying attention to the facial proportions. Fill in the area for the eyes. If you need to, correct any lines with the kneaded eraser. Then use the eraser to carefully work over the basic lines on the outside of the head. These lines should act as a guide and should be barely visible.

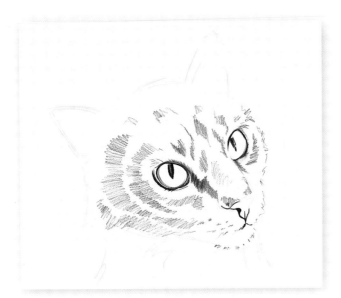

Step 2

With a 4B pencil, add the first sections of fur to the face. Pay attention to the direction the fur is growing and apply soft hatching. Emphasize darker areas with heavier strokes. Enhance the nose and chin with quick, small strokes, and add a few hairs to the cat's chin to draw attention to the contour.

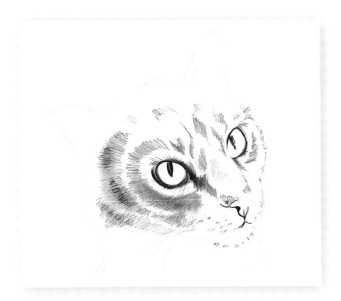

Use long sweeping strokes to capture the unruly nature of this breed's fur.

Step 3

Now carefully blend the hatching a little with your finger, being careful not to smear your drawing. Place a sheet of protective paper on the drawing, and clean your fingers with a damp cloth between blendings.

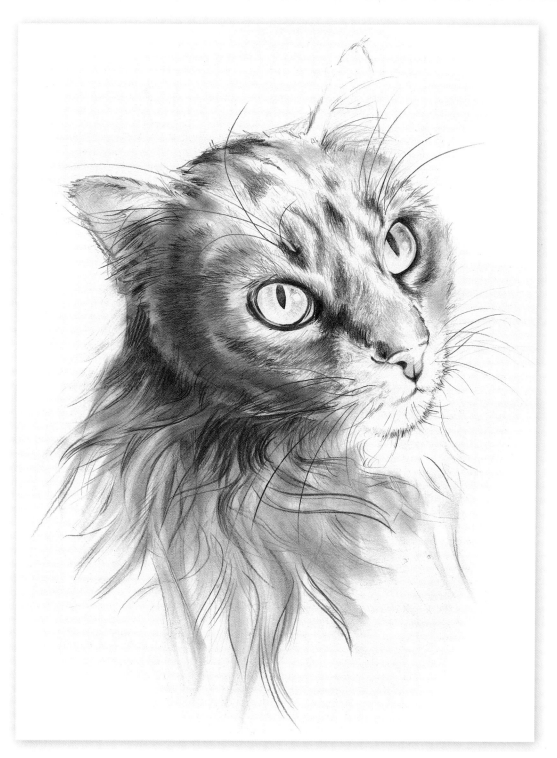

Step 4

Now add some individual hairs over the smudged hatching with more strokes of pencil. If you draw each individual hair gently curving in different directions, you will produce a beautiful texture on the fur. There are also some fine hairs around the edge of each eye. Draw these at regular intervals with pencil strokes extending away from the eyelid. The Maine Coon's majestic fur looks best when drawn with long, sweeping lines.

PORTRAIT GALLERY

Use your newfound skills to practice drawing the cats shown on the next few pages. Happy drawing!

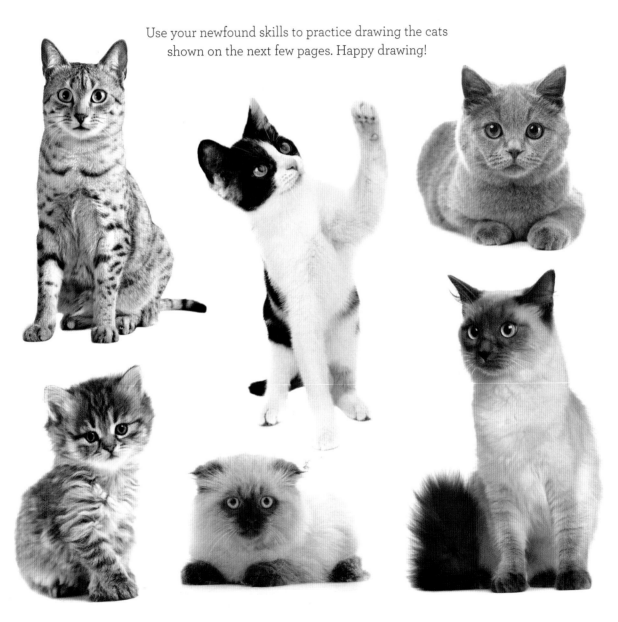

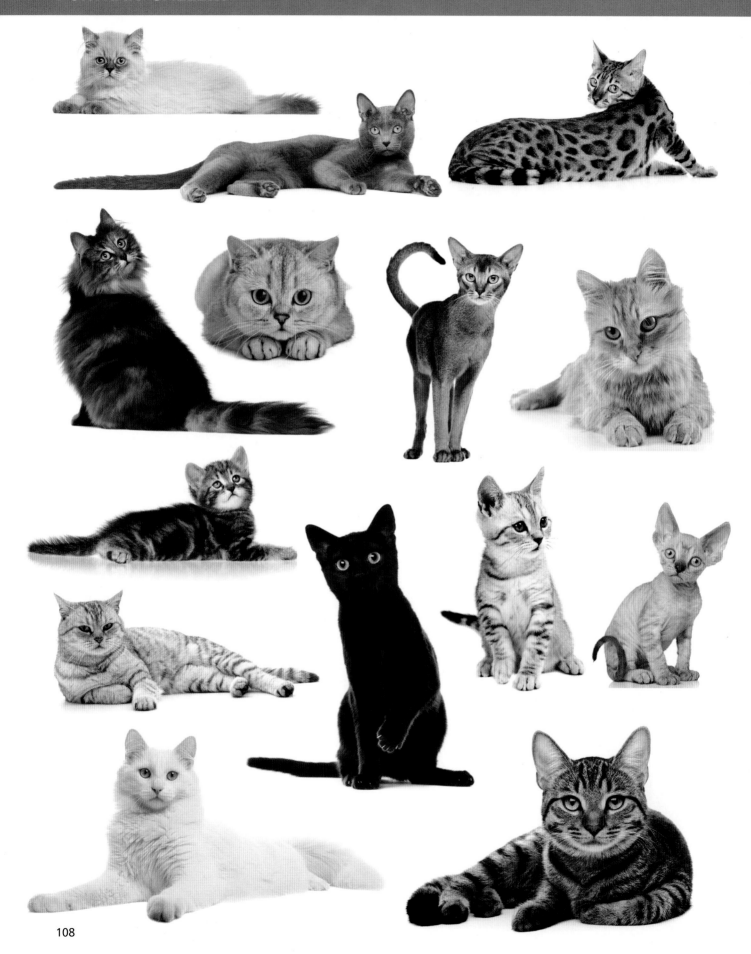

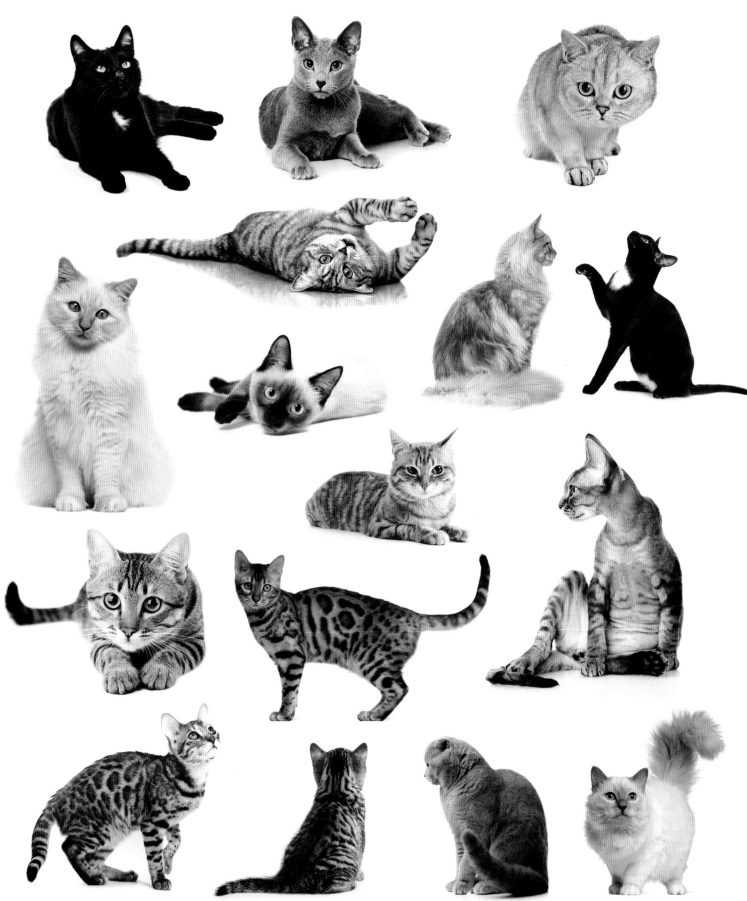

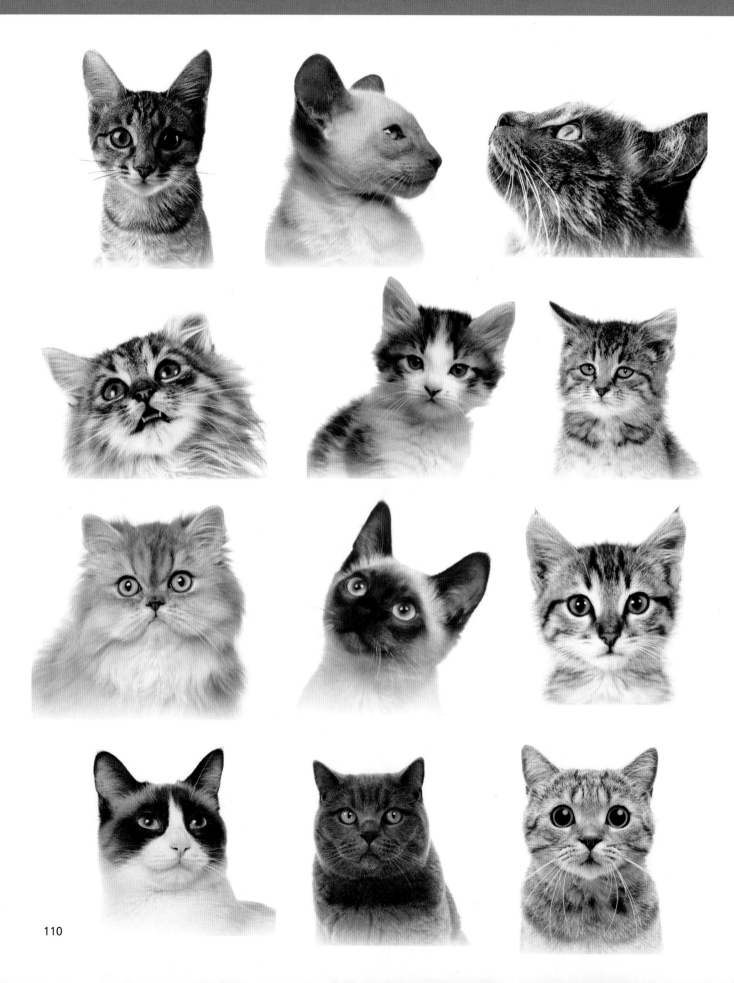

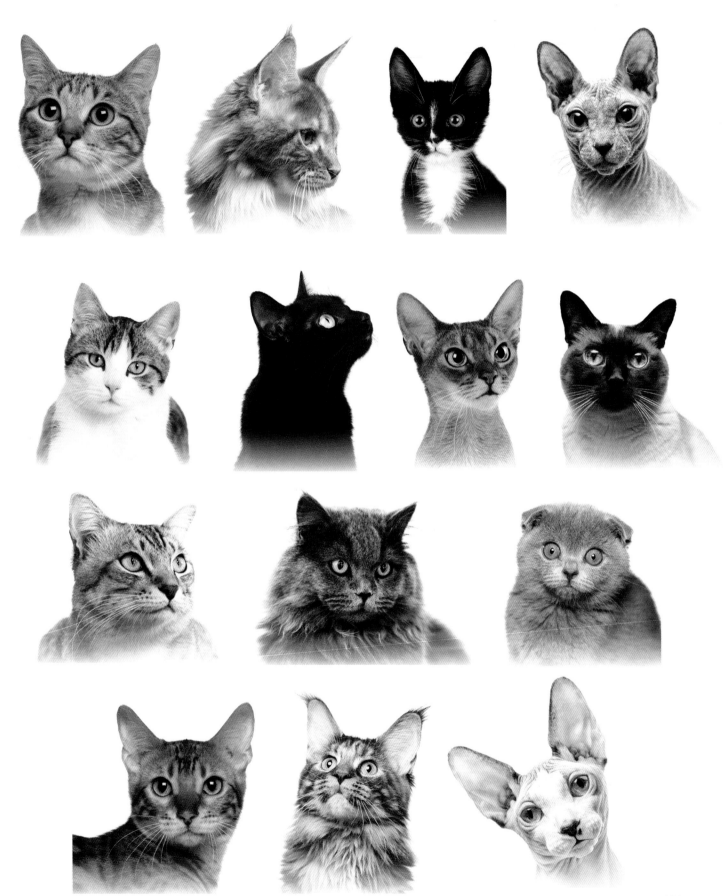

ABOUT THE ARTIST

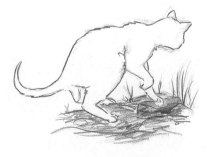

Anja Dahl is a freelance painter and sculptor. She also works as a graphic designer, caricature artist, and illustrator in various fields. Her illustrations have been featured in academic literature, trade magazines, and children's books. Anja is a versatile artist who uses her work to support environmental organizations all over the world.